CARDIFF
IN THE HEADLINES

Tony Woolway

AMBERLEY

I would like to dedicate 'Cardiff in Headlines' to my wife Debra, for all her love and support, and her extreme patience in putting up with me for so long. Also, my two children Jonathan and Bethany, for turning from lovable kids into two brilliant adults. All my love.

First published 2016

Amberley Publishing
The Hill, Stroud
Gloucestershire, GL5 4EP

www.amberley-books.com

British Library Cataloguing in Publication Data.
A catalogue record for this book is available from the British Library.

ISBN 978 1 4456 4888 0 (print)
ISBN 978 1 4456 4889 7 (ebook)

Origination by Amberley Publishing.
Printed in the UK.

Introduction

As a lifelong Cardiffian and working for what seems like an eternity at the *Western Mail* and *South Wales Echo*, more commonly known nowadays as Media Wales, I've seen success, celebrations, tragedy and heartache.

Firstly, for many years as the company's media librarian and today, as syndication executive, I've witnessed all of the above – stories that could fill several books about this historic and vibrant city.

It could quite easily be filled with important dates and historic happenings but this would not show the true nature of what it takes to be a citizen, a true 'Cardiff born and Cardiff bred, and when I dies, I'll be Cardiff dead' chap, as local folk singer Frank Hennessey so succinctly put it in his homage to the city. For many a Cardiffian there has never been a truer statement, such is our affinity to this wonderfully diverse city.

So included with the good and great are the quirky little stories that in many ways show the true character of the city, which did not necessarily make the front page but equally deserve attention.

Spelling mistakes within the newspaper content have been left in to keep the text as historically accurate as possible. The headlines reveal many aspects of Cardiff but what is most evident is that the surface has barely been scratched.

Maybe this book will encourage you to visit your local studies library, of which Cardiff most certainly has one of the best. A vast array of local newspapers are available for the public to research, and they very much need our support.

In ending, I would like to thank Katrina Coopey, Tony Davidson and the rest of the Local Studies team for their help and patience over the years and for maintaining such a wonderful resource to be proud of.

January 1883

THE NEW INFIRMARY AT CARDIFF

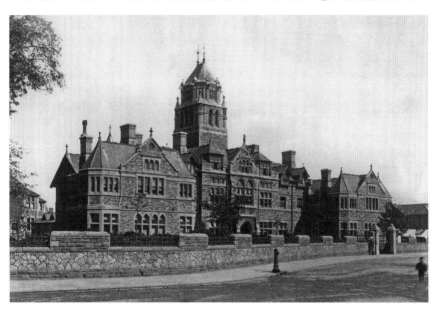

An event which had long been looked forward to with feelings of pleasure by all who are concerned to the welfare of the great charity of the town of Cardiff – the Glamorgan and Monmouth Infirmary and Dispensary – was celebrated on Tuesday in weather which was certainly inclement, but otherwise under circumstances of the most suspicious and favourable character. We refer to the laying of the memorial stone by the most Noble the Marquess of Bute, who arrived in the town on the previous evening from Scotland.

The occasion had many points of interest. His Lordship had, not since the opening of the Roath Basin in 1874, made any public appearance in the town; the institution of the Glamorgan and Monmouth Infirmary had its origin in the suggestion of his noble and lamented father, and the site of the new building of which he was to lay the memorial stone was his own munificent gift. And, in addition to this, the Marquess came to town not only to show his sympathy with the charity which does so much to alleviate human suffering, but also to perform the inaugural ceremony in connection with the construction of a new dock, upon which he is himself about to expend half a million of his money. This event will take place today (Wednesday), and, inasmuch as the undertaking is designed to confer incalculable benefit upon the town and its neighbourhood, the visit of the Marquess is one to which great importance is attached. This was evident from the aspect of things in Cardiff on Tuesday. The presence of Lord Bute at the castle was everyone's topic of conversation, and in all the principal thoroughfares there was a profuse display of bunting. The town seemed to have put on its holiday dress, and even the occasional heavy showers of rain could not damp the festive spirits of its inhabitants.

February 1884

THE LLANTRISANT CHILD-BURNING CASE

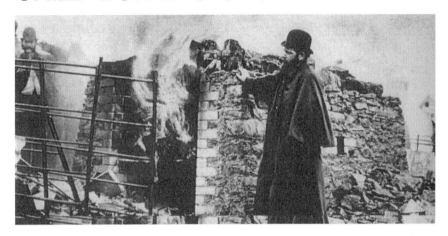

At the Glamorganshire Assizes, at Cardiff, on Saturday, Dr William Price, of Llantrisant, was arraigned a second time on the charge of having committed a misdemeanour by burning the body of a child under circumstances which have already been reported.

The defendant was tried on the same indictment on Friday, but, the jury being unable to agree on a verdict, he was discharged. A fresh jury having been empanelled and sworn.

Mr G B Hughes, who appeared to prosecute for the Crown, said: "After fully considering all the circumstances of this case with my learned friend, Mr Francis Williams, and considering what took place yesterday, I have arrived at the con-clusion that the best and most desirable way will be not to proceed further with the charge. I may further say, my lord, with regard to that most elaborate opinion – more than opinion, judgement – which your Lordship gave, with a review of all the authorities on the great matter of cremation – that, of course, was out of the case, and there will be no opportunity of raising it – looking at that, and all the other circumstances connected with the case, I think I can fairly, without deviating from the duty I owe to the Crown, refrain from offering any further evidence in this action. One word only I will add, and that is this, after the decision of your Lordship that cremation is not illegal, I can only hope that, if it is practised on any subsequent occasion, it will be done under less painful circumstances and in a different was to that adopted by the defendant in this case.

The Judge, addressing the jury, said: "The learned counsel, for reasons which I entirely agree, offers no evidence in this case, and it will, therefore, be your duty to say that the defendant, Wm Price, is not guilty of the charge laid against him. The matter has been one of considerable importance, and I have endeavoured to discharge my duty in regard to it. I gave my reasons as fully as I could for the view I took, and I have nothing to add or alter, or explain in what I have said. No doubt it may in some way possibly be an inconvenience in our

mode of procedure, when a judge delivers an opinion undoubtedly in favour of the accused, that there is no means of testing the soundness of that opinion. But that cannot be helped. I have given my view, and it must go for what it is worth, unless the question arises again. I think I may say to you formally, but really to the defendant Price through you, that people may hold the view that the practice of burning is better than the practice of burial, but we must remember, what everyone in this world would do well always to bear in mind, that they ought to regard the feelings of other people, and there is no subject in the world upon which mankind feels more deeply than about the treatment of the dead. Feeling – I do not say it is altogether a reasonable feeling, I do not think it is – is shocked at the burning of a body, although it may be burned to prevent a more horrible process. Still no one who is accustomed to mankind can possibly be surprised that people should feel very strongly on that subject. Therefore, If a man determines to do so unusual an act – an act which is so likely, to say the least, to be misunderstood, and give offence to a great number of people – it is not only hi legal but his moral duty to use every possible means for preventing offence and annoyance to his neighbours, and to prevent his neighbours having their attention directed to what was going on. I think that in regard to the defendant Price, now he is acquitted, I am sure he must feel that he has been fairly treated on this occasion. I hope he will take what has been said in good part, and I also hope that he will live to enjoy the vigour he now seems to enjoy, and which does not fall to the lot of many of us, for a good many years to come. I am sure, although he expressed the intention of burning himself if he cannot find anyone else to do it, it is not his wish to give offence to his neighbours, and I hope they. On the other hand, will tolerate and old man's eccentricities and peculiar views.

Dr Price then made a very profound bow to his Lordship and left the court.

April 1888

FOOTBALL – WALES V IRELAND (FIRST INTERNATIONAL RUGBY GAME TO BE PLAYED IN CARDIFF)

This international match was played at Cardiff before 4,000 spectators. The day was dull and rather cold, and almost during the whole of the match was in progress a drizzling rain fell.

The ground was in pretty good condition, but rather hard.

Previous to the match the chances of the respective teams were regarded as about equal, but when it got whispered that the Irishmen were but an apology of a representative team odds were freely laid on Wales. The result proved that the anticipations were correct, for though Ireland played a splendid game throughout, Wales

defeated them by one goal, dropped from the field and two tries, to a touch-in-goal and two touches-down.

The teams did not arrive on the field until nearly a quarter of an hour after the advertised time. The Welshmen in their scarlet jerseys, with the Prince of Wales feathers as a badge, were first to put in an appearance. They received a hearty cheer on entering the field. The Irishmen on entering, were cheered more loudly if anything. They wore white jerseys, with a shamrock badge.

After a short delay Ireland kicked off, and the forwards followed up so well that the ball was kicked past the Welsh back, over the line and out of the field before spectators properly knew that the game had begun.

Barlow made a good kick in return but the Irish forwards again made an attack on Wales's territory, and seemed bent on carrying the ball before them by combination. Taylor got hold, however, when the ball got within the 25 and made a good drop into the centre of the field, where the ball was knocked into touch. The throw out resulted in a loose scrummage, which developed into a packed one near the middle of the field. Out of this Handcock got the ball and passed to Taylor, who made a splendid run to within Ireland's 25, where he was collared. A scrimmage ensued, out of which D. F. Moore got hold and attempted to pass to Padlow. Though the latter was collared before he could get away Ireland gained a little ground by the loose play and the ball soon found its way to the centre of the field, where it went into touch.

After the through out, Handcock got hold and passed to Norton. The latter again passed to Taylor, who made a splendid run into Ireland's territory. He was collared near the 25 flag, and as the Welsh forwards had not followed up well the Irish back made a good return. The Irishmen however kept the ball amongst them , and by another combined rush again kicked the ball over the line and forced Barlow to touch down in self-defence. Ireland made a good return after the kick off, but the ball was sent back into midfield by the Welsh backs. After a bit of loose play of an unimportant character, Wales got the ball amongst them, and by a careful bit of nursing dribbled within Ireland's 25. A close scrimmage took place, and the Warren relieved the pressure by a splendid run to the centre of the field, where the ball went into touch.

After the throw out Warren again got hold and nearly crossed the line before he was splendidly collared by Barlow. A little loose play ensued near the goal line, and then D. F. Moore got hold and passed to Eames, who made a bold attempt to scramble over the line. A tight scrimmage followed, and the Welshmen, getting the best of it, relieved the pressure, which was beginning to look dangerous.

Taylor got on the ball in some loose play which followed, and, taking advantage of his Association experience, made a splendid dribble to the centre of the field, where the ball was kicked into touch. Stadden got hold after the throw out, and passed to Norton, who again passed to Taylor. The latter made a good run, and carried the ball into Ireland's 25, where a loose scrimmage took place, and when Ireland just seemed to be getting the best of the scrimmage Stadden picked it up, and dropped it over the bar beautifully. The cheer which rewarded him was loud and prolonged.

The kick off was a rather feeble one, and so was the return. Warren made a good run immediately afterwards, and the Welshmen soon found the ball within their 25 when half-time was called.

Simpson kicked off after the usual rest, and Moore quickly returned

the ball to neutral ground, where it went into touch. After the throw out the Welsh backs got the ball, and by a splendid bit of passing gained considerable ground. Shortly afterwards they repeated the same tactics, Stadden, Norton, Taylor, and Handcock playing together splendidly. Handcock was like an eel, and got through the Irishmen in a manner that was surprising. By a grand run he brought the ball on to the goal line, and after a little scrimmaging Clapp got it over amid cheers. The difficult place kick failed.

Ireland were not at all disheartened by these reverses, but continued to play up pluckily. The Welshmen were too good for them however, and soon scored another try before the call of time, Norton getting the ball over by a fine bit of play.

When no side was called, Wales was declared the victors by one goal and two tries to a touch-in-goal and two touches down. The game was exceedingly fast throughout, and at times highly exciting. The Irish forwards played together splendidly, and has they backed as the Welsh forwards were the result would probably have been very different. Clapp, Hinton and Goldsworthy were the best of the Welsh forwards, and the whole of the backs played splendidly, the three-quarters distinguishing themselves particularly.

The following were the teams :-

Wales: T.M. Barlow (Cardiff), back; F.E. Handcock (Cardiff), C.G. Taylor (Ruabon and HMS Marlborough), and W.B. Norton (Carmarthen), three-quarter backs; W.H. Gwynne (Swansea), and W. Stadden (Cardiff), half backs; H.J. Simpson (Cardiff), T.J.S. Clapp (Newport), R. Gould (Newport) II. S. Lyne (Newport), J.S. Smith (Newport), J.T, Hinton (Cardiff), W.B. Roderick (Llanelly), W.D. Phillips (Cardiff), and H. Goldsworthy (Swansea), forwards.

Ireland: R.W. Morrow (Belfast), back; E.H. Greene (Dublin University), and J. Pedlow (Lurgan), three-quarter backs; R. Warren (Lansdowne), and II. F. Spunner (Limerick). Half backs; D.E. Moore (Wanderers), L. Moyers (Dublin University), A.J. Hamilton (Lansdowne), Eames (Dublin University), J. Fitzgerald (Wanderers), H.J. Cook (Lansdowne), F. Pardon (substitute), and C. Jordan (substitute), forwards.

February 1886

CARDIFF EXCHANGE BUILDING

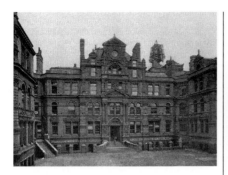 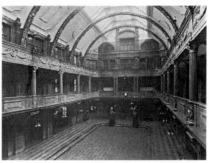

As the new Cardiff Exchange, which forms part of the magnificent block of buildings illustrated above, will be formally opened today (Monday), a brief history of the scheme and description of the structured will, doubtless, be read with some interest by those connected with the port who know how urgent has been the need for a fixed place of meeting, in which merchants, freighters and brokers of the Docks might arrange their business transactions.

The ceremony of today will possess considerable interest, not only on this account, but also because the building is one of the finest in South Wales. Cardiff has been slow to follow the example of other large towns, but, now that the step has been taken, it is gratifying to note that her Exchange will bear favourable comparison with almost any structure of a similar nature in the kingdom.

The desirability of establishing an Exchange for the coal and shipping trades in Cardiff had been frequently been forced upon the minds of many gentlemen, who felt the inconvenience of having to rely upon chance meetings in the street or cursory calls at each other's offices to transact their business, but it was not till 1883 that any practical step was taken. The Cardiff Exchange Company Limited was formed, with a nominal capital of £50,000 in shares of £20.

Among the chief promoters of the scheme were Colonel Hill, C B., Messrs, E Jenkins, J H Wilson, L Gueret, E C Fry, F Hacquoil, and C E Stallybrass, while shareholders included such men as the Marquess of Bute, Sir W T Lewis, and Sir Edward Reed, MP.

Various sites at the Docks having been considered, it was finally decided to erect the building, if possible, on open ground in Mount Stuart Square. The secretary of the company communicated with Sir W T Lewis, with whom terms were arranged, and sketch plans prepared by the architects, Messrs Seward and Thomas, having approved, work was proceeded with at once, from plans prepared on their basis. At starting considerable difficulty was anticipated in meeting with proper foundations for so extensive a building, but it was not until trial shafts had been sunk by the builder, to whom the contract for the first part had been let at £25,000, that the true state of affairs in this respect was ascertained. The site was found to be composed almost entirely of the alluvial mud which prevails in that district. The sub-stratum was found to be about 30 feet in thickness and of the consistency of butter. In certain places, also, the ground had been honeycombed and filled in with slag from the old Cardiff Glass Works, which existed about half a century ago on that portion of the moorlands now occupied by Mount Stuart Square and its surroundings. Few more serious problems could present themselves to everyone concerned than to erect a massive building upon such ground as this, and a solution of the difficulty was

regarded, not only with anxiety, but interest.

After considerable deliberation the directors agreed to the proposal of the architects to excavate the mud until gravel is reached. When this was accomplished it was obvious that, owing to the large number of buildings in close proximity, it would be dangerous to proceed in the customary manner with trenches for foundations, so the plan adopted was that of sinking a series of shafts, but these had necessarily to be very small, owing to the treacherous nature of the surrounding mud. Concrete was then filled in, and upon the piers built thereon were constructed massive arches, on which the whole building has been erected. The perfectly stable result shows with what care and excellence the work has been carried out.

It should be remembered to the lasting credit of the promoters, that, despite the troubles and difficulties they had to encounter, they still persevered in the enterprise, and, although the cost has necessarily been very great, it is gratifying to know that through important concessions made by Lord Bute the shareholders will in no way suffer.

March 1886

EXPLOSION AT CARDIFF DOCKS

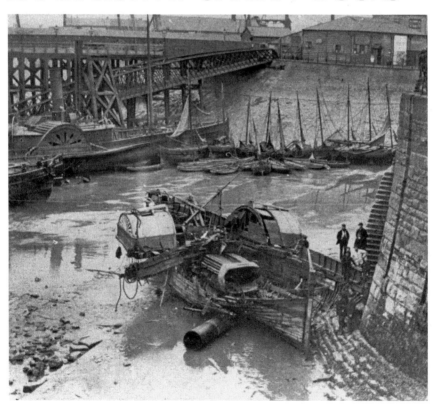

SCENE AT THE EXPLOSION

The boiler explosion on board the steam tug Rifleman at Cardiff Docks yesterday morning was a very disastrous affair, resulting, as it did, in the instant death of five men, the probable death of one other, and severe injury to a seventh man and a boy.

The vessel itself in which the catastrophe occurred collapsed and almost sank immediately., the Pierhead at once becoming a dismal scene of maimed and dead men in the midst of hundreds if not thousands, of the living, of whom many appeared overwhelmed by the magnitude and suddenness of the calamity.

The force of the explosion might easily be judged by the fact that the shell of the exploded boiler, projected nearly a quarter of a mile away, killed in it's descent a poor man who was standing on the deck of a small ship, thinking, we may easily suppose, of anything but terrible danger and death that were awaiting him. The bodies of some of the poor fellows hurled high in the air – those of the captain and mate have been described as shot at least thirty feet over the clock tower of the Pierhead – came down with a thud to earth, presenting the most sickening spectacle, and all together the horror of the scene was such as from a single and comparatively insignificant cause it would be difficult indeed to surpass. That the catastrophe was due to an explosion of the boiler there appears to be not the remotest of doubt. What brought the explosion of course, would be subject of judicial investigation.

Boiler explosions are oftenest the caused, we think we are right in saying, either from a weak spot in the plating or from running low on water. The latter is suppose to be the case here, although as to what the precise cause was is hard to see how a perfectly satisfactory conclusion can be arrived at. With the improved modern water gauge explosions from this cause are not such a frequent occurrence as they used to be, when the test was a tap from which it was hard to tell whether you got water or steam. Even the modern gauge, however, is liable to go wrong – so much so, that a man of old fashioned ideas has been heard to call it a danger-trap rather than a trustworthy safety signal.

October 1888

'JACK THE RIPPER' WRITES TO THE *WESTERN MAIL*

On Wednesday morning we received the following letter, bearing the London postmark, October 9, and addressed to The Editor, Western Mail, Cardiff , S. Wales.

Dear Old Boss, - What do you think of my little games here - ha! ha! Next Saturday I am going to give the St Mary St. girls a turn.

I shall be fairly on their track, you bet. Keep this back until I have done some work. Ha! ha! Shall down Friday.

Yours,
Jack The Ripper (trade mark)

The communication is written across a half sheet of plain notepaper, and the phraseology, it will be noted, is similar to that of the letters sent to the Central News last week. "Dear Old Boss," "ha, ha," "give them a turn", "on their track", and the broken sentences all indicate that the letter was written by the same hand, or that the writer has slavishly copied the original missive.

That these communications have no other intention than to unnecessarily agitate the public, we have not the slightest doubt; and we need hardly add that no importance need be attached to what appears to be, on the face of it, a grim practical joke.

The Central News states that up to eleven o'clock on Wednesday night no further arrests had been made in connection with the Whitechapel murders.

A reporter who patrolled the East End districts says the popular excitement has almost entirely subsided. More women were on the streets than had been seen for weeks past, and there were no signs of special police precautions.

It is understood, however, that the police have in no degree relaxed their vigilance, and a number of plain clothes men and amateur patrols have been introduced.

November 1888

WAS THE 'RIPPER' SPOTTED IN ROATH?

On Sunday morning the inhabitants of the poorer localities of Roath, Cardiff, were thrown into a state of unwanted excitement by a rumour, which soon became current everywhere in the district that a man answering to the description of "Jack the Ripper" had visited a shop in Roath.

In a short time the police got wind of the rumour, and making inquiries found that between ten and eleven o'clock that morning a strange looking man, about 5ft 10in, in height, with a black leather bag in his hand, had entered the shop of Mr Hardell,

hairdresser, Broadway, and after glancing suspiciously at the customers present, said he wanted a shave.

The room at the time was filled with working men, who, while waiting their turn were freely discussing the latest tragedy in Whitechapel, in the course of which, one of the company remarked that he could not for the life of him see how a man could cut a woman's throat and afterwards mutilate a body without his clothes becoming bespattered with the blood of his victim.

The suspicious-looking stranger, who up to this time had been sitting list-

lessly on the seat, suddenly jumped up in an excited manner and said he was a professional butcher, and could with ease cut either a man or woman's throat without a speck of blood getting on his clothes.

He then volunteered the information that he had arrived from London, and that he was then off to Newport, and left the shop as strangely as he had entered.

During the day the police made inquiries for a man answering the description given by several who were in the shop, including Mr Hardell, but without result.

May 1897

TELEGRAPHY WITHOUT WIRES

Marconi invention tested at Lavernock

 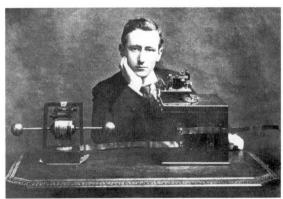

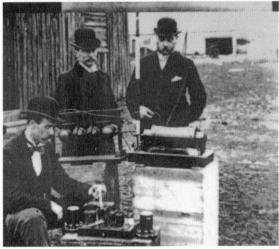

The postal authorities of the country have evidently faith in the possibilities of the Marconi system of telegraphing without wires, and the Italian inventor (M. Marconi) has reason to feel proud of the success of the demonstrations, so far as they have yet been carried out.

Marconi, as reported the other day, successfully carried out on Salisbury Plain a series of experiments with a couple of balloons attached to wires to the ground.

For several days past he has engaged in conducting experiments at Lavernock Point, near Cardiff, in testing the effective working of his system of telegraphing without wires between the mainland and the Flat Holm and trials have been witnessed by Mr Preece, engineer-in-chief of the General Post Office; Mr Garvey (late of Cardiff) now second engineer in London; Mr Fardo, Cardiff postmaster, and other officials of the department.

For the purposes of the experiments, Mr Williams (of the engineering department, Cardiff) fixed upon Lavernock Point a pole 120 feet high, with a zinc cylinder at the summit, 5ft 6in by 4ft, insulated from the Flat Holm and Brean Down.

The experiments on Tuesday were not so successful as might have been desired, but on Wednesday

and Thursday the results were most satisfactory. On Friday afternoon there was a semi-public demonstration, when the system was explained in miniature, a transmitter facing a receiver at a distance of some twenty yards.

June 1897

CARDIFF CELEBRATING THE DIAMOND JUBILEE – FORMAL OPENING OF THE NEW VICTORIA PARK

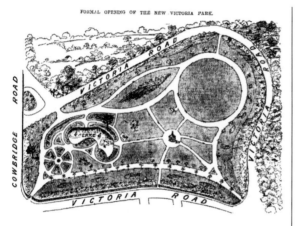

FORMAL OPENING OF THE NEW VICTORIA PARK.

The opening of Victoria Park, at Canton, Cardiff, on Wednesday by the mayor (Alderman Ebenezer Beavan) is the first act of the corporation of the town in celebration of her Majesty's Diamond Jubilee, and, favoured by fine weather, the function was a decided success.

It has not been without great expense and unavoidably long delays that the inhabitants of the western portion of the borough have been provided with gardens and recreation grounds, which they can reasonably demand after contributing for many years to the laying out and beautifying of the Roath Park at the eastern end of the town.

The corporation obtained powers as far back as 1875 to acquire the Ely and Canton Commons, and the money which under that Act they were allowed to borrow was only £4,000. Unfortunately, the corporation had not only to deal with the lord of the manor (who in this instance was Mr Cartwright), but with and ever-increasing number of persons who claimed common rights in one form or another.

June 1899

A CARDIFF RIVAL TO "WIRELESS" MARCONI

Complete annihilation of distance

Scheme under government consideration

Every man finds his equal in some corner of creation, and at last a rival to Marconi has been discovered in the person of a young man bearing the inapt name of Smith, and engaged as a working tin man at Cathays, Cardiff.

It goes without saying that he is a man of great intelligence, and, of course, was born with his head full of experiments and inventions.

He is now engaged in hatching his mental eggs, chief among which are two systems of wireless telegraphy, one being an improvement on Marconi's arrangement, for which he obtained provisional protection, and the other a system of combined wireless telephonic and telegraphic communication, which Mr Smith maintains beats creation.

Questioned by our science man on Friday as to what had first directed his attention to these matters, Mr Smith said that when he was not hammering and soldering tin pots he had twelve months or so been engaged in studying various systems of wireless communication, and had read all the class papers could tell him about the subject.

A born Welshman, with a genius for competition, something of a patriotic impetus had been given to his studies by the spectacle of the kudos gained in this direction by foreigners and he had set himself to discover whether he could not go one better than Marconi.

He has reduced the results of his studies to writing, and one system is sufficiently advanced to enable him to comply with the requirements of the Patent Office in the matter of obtaining provisional protection.

He has not yet engaged in actual experiments from shore to shore.

Unfortunately for struggling genius, experiments cost money, and Smith has only been able to spare a few bob a week for the furtherance of his ambitions. But hope springs eternal in the human breast, and that generous patron of art and science, the British Postmaster-General, will take the matter up, and enable him to hatch his ideas.

Smith wrote to the Postmaster-General this month offering to put the Channel Islands into telegraphic and telephonic connection on the wireless principle with the South Coast of England at any desired spot.

This should appeal to the Postmaster-General, for, apart from the danger of revolting, the Channel Islands cable is continually breaking down and calling for much expenditure in the way of repairs.

Apparently it has so appealed, for the Postmaster-General asked for full particulars, which Smith sent to London this week. Smith has also proposed to that other great patron of genius the President of the Board of Trade to put any lighthouse into telegraphic and telephonic connection with the shore.

The business is too intricate for mortal ken to grasp, but Mr Smith talked a lot of "better transmitters," of "sensitive coherers" and "receivers," and of "focussing the rays" - matters which one would

only render more obscure by entering details.

However, it seems clear that one of the great advantages of Smith's system is that it tells no tales. Absolute secrecy is one of its distinguishing traits, and the author declares that one of his apparatus will give satisfactory results, telephonic or telegraphic, for any distance up to 150 miles, "without the wire," explained Mr Smith to our man, "my apparatus can be put on a table or anywhere else, and can send a message through a window or a wall. It can go at a very high rate of speed. Marconi sends at a rate of sixteen words a minute. My apparatus can be worked by a Wheatstone machine at any rate up to 400 or 500 words a minute, while a telephonic conversation can be carried on from shore to shore equally as well as by two persons at the end of a wire on land. Have you anything else on hand?

"I have an idea for a seeing as well as hearing telephone, an apparatus which will transmit colours of goods or sample, and enable them to be seen as well over wires as if they were in the same room. Then there is the picture phonograph, for transmission of pictures. But all these things must stand over until the result of my offer to the Postmaster-General transpires,"

So the future of the world's progress hangs now on the shoulders of his Grace of Norfolk.

June 1910

WORLD SKIPPING CHAMPION

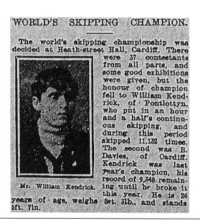

WORLD'S SKIPPING CHAMPION.

The world's skipping championship was decided at Heath-street Hall, Cardiff. There were 37 contestants from all parts, and some good exhibitions were given, but the honour of champion fell to William Kendrick, of Pontlottyn, who put in an hour and a half's continuous skipping, and during this period skipped 11,132 times. The second was B. Davies, of Cardiff. Kendrick was last year's champion, his record of 9,348 remaining until he broke it this year. He is 26 years of age, weighs 8st. 3lb. and stands 5ft. 7in.

Mr. William Kendrick.

The World's skipping championship was decided at Heath Street Hall, Cardiff.

There were 37 contestants from all parts, and some good exhibitions were given, but the honour of champion fell to William Kendrick, of Pontlottyn, who put in an hour and a half's continuous skipping, and during this period skipped 11,132 times. Second was B Davies, of Cardiff.

Kendrick, was last year's champion, his record of 9,348 remaining until he broke it this year. He is 26 years of age, weighs 8st 3lb and stands 5ft 7in.

August 1910

WILLOWS FLIGHT
Airship record – Cardiff to London

Landed London 6.15. Had safe journey – WILLOWS

This was the laconic telegram from Mr E T

Willows, to the "South Wales Daily News," was

the first intimation received in Cardiff that the plucky young aviator had succeeded in his endeavour to navigate his dirigible balloon from the capital of Wales to the capital of the Empire.

Incidentally he also succeeded in putting up a new "distance record" for British dirigibles.

The historic journey was accomplished during Saturday night and the early hours of Sunday morning.

The distance from Cardiff to the Crystal Palace is about 150 miles.

Starting from Cardiff at 8.5 o'clock on Saturday night Willows crossed the Bristol Channel to Clevedon, passed over Bristol and Twerton and though he lost the motor-car which was to guide him to London, he never the less was hovering over the Crystal Palace, his objective, at 5.40 on Sunday morning.

Through the breaking of a rope after he had sent out his grappling irons, he was unable to descend at the Palace, the "ship" rising again, and, the aviator's petrol being exhausted, drifting over London.

By the aid of a gardener, who caught the rope, Mr Willows succeeded in alighting about four miles from Crystal Palace at Lee, near Catford.

July 1915

VC BARTER

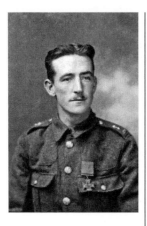

Wounded at Cardiff by chocolate bombardment Company-sergeant-major Fred Barter, VC, arrived at is home in Daniel Street, Cathays, Cardiff, on Monday evening with the bridge of his nose skinless. The injury was not caused by the enemy, but by his own friends and admirers.

When he was torn away from the clinging embraces of the crowd and landed with difficulty in the passage of his father's house by Superintendent Bingham and Detective-inspector Harris the hero of Festubert was almost limp with the strenuous-ness of his experiences since his arrival in the city, and he flopped into the nearest chair as soon as he had kissed the relatives and old friends who had stayed in the house rather than face the crush of the throng.

He was a happy man, notwithstanding his injured nose, and his kindly, well-formed fea-tures were a picture of happiness, although his blood-stained handkerchief made alternate journeys to his nasal organ and to his eyes, which were now and again welling with tears of joy as his dear ones came to shower him with their felicitations on him.

"What has happened to your nose?" asked the Western Mail reporter who had gained access into the house just before the door was barred by the police against the rush of the cheering crowd.

"Oh I was hit with a box-ful of chocolates on my way up," was his smiling reply.

"The people were so kind that they simply overwhelmed me, and the young lady who threw those chocolates is freely forgiven for the kindness which accompanied her blow."

The sergeant-major was evidently in great good humour, and continued with the remark:-

"It has been immense hasn't it? How I got here at all through the wonderful cheering crowd I cannot imagine. It was not my fault, please understand," he said, with another laugh, "because I did all I knew to come back quietly.

"I'll tell you a little joke to prove it. When I was seated on the train at Paddington I could see a railway inspector going from compartment to com-partment asking every man in khaki his name and destination.

"It dawned on me that they were in search of inno-cent me, and when he came up to me I replied that my name was Williams. Whether I failed to carry the joke well or not I do not know, but he seemed suspicious, and began to take stock of my kit. At last he found my label and my name, and then the game was up.

'I have got you at last, old chap,' he said, and after giving me a hearty handshake, made off for the telegraph office.

"I guessed the rest, and the reception that dear old Cardiff has just given me shows that he did peach on me by wire!"

The fact is that the Lord Mayor of Cardiff had arranged with Mr J Vaughan Williams, the Great Western Railway divisional superintendent, that the 3.30pm train at Paddington should be searched for the elu-sive hero in order that his arrival at Cardiff on 6.30pm train might be placed beyond doubt.

May 1921

GLAMORGAN DEBUT AS FIRST CLASS COUNTY

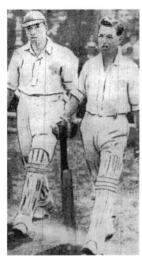

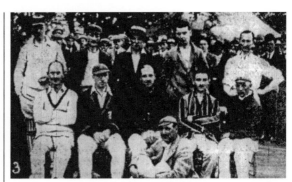

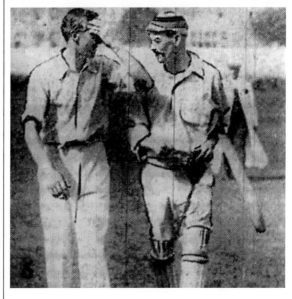

Today is a notable day in the history of Welsh cricket. Glamorgan will play its first match as a first-class county. The opponents will be the Sussex eleven, one of the strongest elevens in the country this season – and the match will take place at Cardiff Arms Park, wickets being pitched at noon.

The admission of Glamorgan to the ranks of first-class county talent is the realisation of the dreams and hopes of a small band of enthusiasts who, whilst rejoicing at the pre-eminence of the Principality in football, saw no reason why a bid should not be made for equal prominence in the greatest of our national games.

The story of how realisation was attained, and especially the splendid persistence of Mr T A L Whittington, has been full told in the columns of the Western Mail. It now remains for the public to do its part. Nowhere in the country is there a greater appreciation of high class sport than in South Wales. Today South Wales will have

the opportunity of seeing cricket at its best. Everything possible has been done for the comfort of the public, and it is hoped that the attendance will be worthy of the occasion. Ladies are especially invited.

Cardiff Arms Park has never looked more attrac-tive than it does today, and it is safe to predict that the visitors, not one of whom has ever played at Cardiff, will be charmed at seeing such a delightful county ground in the heart of the city. Nash has prepared an excellent wicket, and if the fine weather continues, Glamorgan's first match as a first class county should prove a record in every way.

Footnote : Glamorgan won their first match as a first class county defeating Sussex with 23 runs to spare, in front of over 7,000 spectators.

February 1925

FUNERAL OF JIM DRISCOLL
Wonderful tributes to Jimmy Driscoll

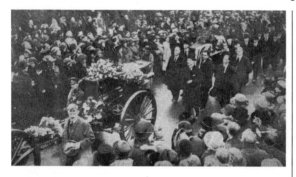

Wonderful scenes marked the funeral of Jim Driscoll, the world renowned boxer, at Cardiff today, and it is estimated that 100,000 people lined the route from the house along the main streets through which the cortège passed.

Personalities famous in every branch of sport travelled from all parts of the country to walk in procession – nearly a mile long – to the graveside.

The Driscoll home in Ellen Street was quite una-ble to find room for the huge number of floral tributes, many of which had to be temporarily accommodated in neighbouring houses.

Crowds in the street witnessed an inspiring spectacle, and at the graveside the last rites revealed one of the greatest tributes that has ever been paid to one of Cardiff's citizens.

Over 100,000 people, lining the streets of the city, watched the funeral of Jim Driscoll, the man that brought such tributes from all walks of life.

His wizardry in the ring earned him undying fame as a boxer, the big-heartedness of this great personality of the boxing world, which found expression in the life of a true sportsman, one ever ready to help with word, or act, a deserving cause, that touched the

mainspring of general appreciation, and unloosed the floodgates of public sympathy and respect.

It would be impossible to imagine a more solemn and impressive scene than that in Ellen Street, when the coffin, draped with the Union Jack, was lifted shoulder high by his pals and taken to St Paul's Church.

As the clock approached the hour for the procession, it was almost impossible to pass along Bute Street, thronged along Tyndall Street and by two o'clock it was one huge seething mass of humanity.

When the cortège was timed to leave the house, thousands of people, of every age, of every station in life, and all sections of society had gathered in the vicinity.

Docks-men, miners, trimmers, seamen, businessmen, boxers, men of all callings, mingled together, and when the area became so congested , they had recourse to the dock walls, from where they had a bird's eye view of one of the most remarkable funeral processions ever held in Cardiff.

Even though Tyndall Street was crowded, it was nothing to compare with the tumultuous concourse of people who lined Bute Street. It was so dense that the policemen had recourse to stop all traffic coming into Bute Street from every direction.

St Mary Street held thousands of spectators as the cortège passed through. Throngs of people fought for room to get a glimpse of the procession as it passed.

Arcades and by-streets resembled bee hives as one viewed the scene from the Monument. All traffic came to a standstill, and tens of thousands of men bared their heads. All the business establishments along the main thoroughfare ceased operations for a brief period.

April 1928

DOG RACING COMES TO CARDIFF

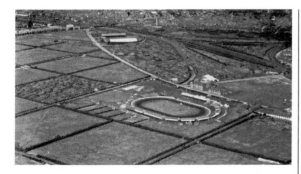

Mr J J Cronin, the noted Irish greyhound owner, has five dogs kennelled at Sloper Road, and these have done exceptionally well in the coursing field during the winter season. They will doubtless prove a great success on the racing track.

On Friday night a dress rehearsal was held and the public admitted. Four flat and one hurdle race was run, and several of the dogs returned good times. Spectators were delighted with the beautiful effect

Cardiff's first greyhound racing track is open to the public at Sloper Road, Grangetown, tonight.

One hundred and thirty dogs are now kennelled at the Welsh White City in readiness for the Easter week racing, and a considerable number of them are well known to the public, having won races on all the big greyhound tracks in the country.

of the racing track under the powerful glare of the arc lamps.

Tonight's programme is an exceptionally fine one. Local interest centres chiefly in the match between Fred Keenor, the popular Cardiff City captain and Gillespie, the Sheffield United captain.

The match is for 25 gns cup presented by the Greyhound Racing Association, and will be contested for by Bargains Hill, Keenor's dog and Begerins Lass. There is no form whatsoever to go on and selecting winners will be a difficult task.

Bargains Hill and Begerins Lass have dead-heated in trials and on each time they have been out they have returned similar times.

Public opinion will be in favour of Bargains Hill, who will probably be the favourite, but preference is given to Begerins Lass. The race will be a very keen one and much will depend on trap position.

Footnote : The cup was won by the Sheffield United captain Gillespie's "Begerin Lass. Fred Keenor collected the trophy on his behalf.

March 1929

CARDIFF FIRST TALKIE

The management of the Queen's cinema, Cardiff, are to be congratulated upon the success of their efforts in securing and presenting the first talking picture programme in Wales.

Preceded by Val and Ernie Stanton in "Cut Yourself a Piece of Cake" and Martinelli, the great Italian tenor, in "Pagliacci," comes Al Jolson, master of comedy and master of pathos, too, in "The Singing Fool."

Large numbers waited eagerly for each house to open, and were held spell-bound or applauded in appreciation as the power-ful story was told in words, songs and wonderfully clever acting.

All should endeavour to see and hear Al Jolson in "The Singing Fool" at the Queen's. There are four distinct houses daily – 1pm, 3.30pm, 6pm and 8.30pm.

May 1938

BUTE SELLS OFF HALF OF CARDIFF

HALF of the city of Cardiff changed owner-ship yesterday when the board of Mountjoy Ltd, acting for the Marquess of Bute, exchanged con-tracts for the sale to an unrevealed purchaser in London.

After the board meeting of Mountjoy Ltd, it was officially announced:

"We have agreed to sell the major portions of their estates in South Wales to a client of Messrs Wigram and Co, solicitors, of 6 Queen Street, Mayfair.

"The manors and cer-tain other portions of the estates, such as the castles

of Cardiff, Caerphilly, Llantrisant, St Quentin and Castell Coch and their immediate surroundings, the Glamorganshire Canal, Sophia Gardens and Messrs. Mountjoy's interests in the

Cardiff and Penarth road, are excluded from the sale.

"Generally, minerals, already being worked or capable of development, together with surface lands in the mining areas, are also excluded."

It is to be noted that mineral royalties will shortly be acquired by the state and compensation paid.

No indication is given of the purchase price, but an upper limit of £5,000,000 has been mentioned, while it may be below £4,000,000.

Mr W J G Beach, agent to the estate, assured the

Lord Mayor of Cardiff last night that leaseholders' interests had been safeguarded.

The purchase may be regarded as an act of great confidence in the future of the city on the part of people who have watched the steady industrial and commercial recovery of South Wales.

The Bute Estate comprises approximately half the city of Cardiff, a large portion of the Docks area, large agricultural areas around the city and parts of the town of Penarth.

April 1939

"BILLY" THE SEAL IS DEAD

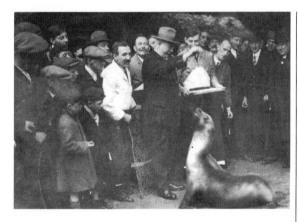

"Billy" the seal, well known to every Cardiffian and to thousands of visitors to the city, is dead.

For 30 years "Billy," as he was popularly known,

had been a great pet and attraction of which the city had been proud. For many a visit to Victoria Park was never complete without a call at the pond where

"Billy" made his home, for he was an understanding creature who always appreciated a small gift in the way of food.

He was a great favourite of the park-keepers who loved him as if he was a child. His meals were big and frequent – but today his keeper, who went along with his breakfast, found "Billy" dead.

"Billy" had a remarkable and eventful career. When the west of the city was flooded many years ago, when the River Ely overflowed it's banks, took advantage of the

high water-level, left his pond and made his way along the flooded footway and streets of Cowbridge Road.

Now Victoria Park is without its pet. Whether or not "Billy" will be replaced his name will always be associated with that picturesque part of the city which he helped to popularise.

Perhaps "Billy" will be stuffed and preserved in the National Museum of Wales, where people will be able to look upon him and recall the days of their childhood when he gave them joy and happiness.

"Billy" is dead, but will not be forgotten by all who knew him.

August 1940

SPITFIRE

Cardiff's first spitfire

Cardiff's spitfire No 1 has been completed. The fund has now reached the £5,000 mark and the Lord Mayor, Alderman Henry Johns, encouraged by the magnificent response, together with the fact that hundreds of collectors are still busy, feels that Cardiff should now push on for a second, and possibly third Spitfire. Indeed a squadron is not too much to expect of Cardiff – so now it is on to the £15,000 at least.

The start towards the second Spitfire has been made with a donation of 100 guineas from Sir William Seager and his sons.

January 1941

FIRE BOMBERS' "BLITZ" RAID ON CARDIFF

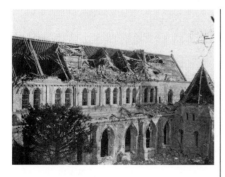

German bombers brought the blitz to South Wales last night when, continuing their fire-raising activities they indiscriminately bombed hundreds of people in Cardiff from their homes.

The raid began at dusk, and, following the usual procedure, flares and incendiaries preceded high explosive bombs of heavy calibre.

Many fires were caused and damage to property was considerable. It is difficult to estimate the number of casualties, but there were some deaths.

It is believed that one enemy bomber was shot down.

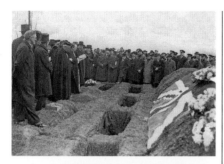

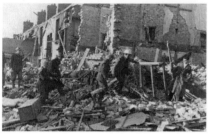

Hour after hour waves of bombers zoomed over the city. Within a few minutes of the commencement of the raid fires lit the sky, and when darkness set in was almost light as day ; but although large numbers of fires were started, even more were prevented by speedy action, for one of the most striking features was the way in which A.R.P. Workers and unofficial volunteers tackled fire bombs.

Indeed although churches and scores of houses were extensively damaged, the community showed itself well able to deal with the situation.

The anti-aircraft guns put up a barrage heavier than as ever been heard in the area; the firemen fought the flames throughout the night under considerable difficulties, suffering some casualties; Home Guardsmen joined the A.R.P. Workers and a army of unofficial civilian workers, including young lads did much to render the incendiaries ineffective.

As usual the Nazi targets included a number of churches as well as homes of working class people. Part of a hospital was also hit.

The raid was widespread. From one district came one bit of bright news. There is good reason to believe that an enemy plane was shot down there. Eye-witnesses declare that they saw the plane "shot to pieces," its last moments illuminated by a cinema fire.

Touring the city earlier this morning a "South Wales Echo" reporter visited a church hall where several hundred homeless men, women and children, were being provided with shelter.

The room was cosy, each occupant was provided with blankets and war-stained civil defence workers served hot tea.

One diminutive lady warden said: "I have not had time to go home all night but I am told part of my house is demolished. But it will make no difference to me. I shall sleep here," she added.

Sitting forlornly on one side was a white-haired, partly blind old lady.

"We have been lying under the bed in a friends house for hours," she said. "We had to leave our own."

One story with a happy ending, which our reporter heard here, came from young Mr Allen, whose home was completely demolished. He told how he had been at work when the raid began, and returned to find his home gone. "I searched for my wife and child and father-in-law everywhere," he said. "I even dug into the rubble in the hope of finding them. After some anxious hours of inquiry I found them safe in this church hall."

Mrs Allen told how the three of them were sheltering under the stairs, a bomb hit the house and they were buried.

"I managed to dig myself out and then set to work digging out my boy and father. When we were free we went into our shelter. No sooner had we settled down than there was another terrific explosion. It is feared that in this particular street a number of persons are still buried.

A young soldier resting at the hall was said to have arrived home on leave that night. He spent the time assisting civilians.

Mr Owen, whose was also damaged, was in the front room with his wife and three children, suffering from measles. They all had to make a hasty retreat. "Five houses near us were wiped away," he said.

Long after the raiders had passed fires burned steadily, but some hours before dawn they were all under control. Included in the list of premises damaged by fire were well-known shops, including an arcade. Five horses were saved when a corn merchant's store was hit.

One man who led a party of residents outside when a fire bomb fell and ignited a gas main, told a reporter that between 40 and 50 men and women worked together in fighting the blaze.

"While members of the ordinary fire services were busy elsewhere," he said, "We formed a human chain along the street and passed buckets of sand from the spot where an air-raid shelter was being built. We emptied the sand on the blaze and it was soon under control."

At the height of the raid the town was deserted. It was only at certain points that any sign of life was discernible. This was in front of buildings which had been struck, where knots of men were at work on fire pumps.

One of the number in each group swung a lamp to warn ambulances, police cars, and fire engines, which were the only vehicles in the streets.

The firemen dealt very effectively with the blazes.

In one street a store was burnt out, but the fire was prevented from spreading. Across the street the shows continued at two or three cinemas. A fire in a shopping centre was quickly quelled.

A church was badly damaged by fire. It was believed not far away an enemy airplane crashed.

One of the smaller streets was badly damaged by fire. Several other streets were ankle-deep in splintered glass.

A.R.P. Workers did excellent service throughout the raid.

An Air Ministry and Ministry of Home Security communiqué stated :-

The main enemy attack last night was a town in South Wales, where considerable damage to houses and to commercial and other buildings.

A number of fires broke out but fire services had extinguished many and brought the rest under control by an early hour this morning.

A number of people were killed and others injured. Bombs were also dropped in other parts of the country, but the damage done was small and casualties were very few.

October 1941

BACK FROM THE DEAD

Cardiff sailors 'Back from the dead'

Two Cardiff sailors returned "from the dead" on Sunday.

For months no one had heard of them. Everyone - except their mothers - believed they were dead.

On Sunday they limped back to the doorsteps of their homes once more, after an experience likened only to Hell.

The boys, still haggard and bowed under the memory of the horrors they

had been through are Thomas Spriggs of Portmanmoor Road and James Sexton of Richard Street, Cardiff.

They were serving as firemen on a Greek steamer. On June 13 they were torpedoed in the Atlantic and only one lifeboat was usable and 27 got into it with room for only 17.

They were in the boat for 17 days getting weaker and suffering from exposure and under feeding. One of the crew died but the rest stuck it out until they found their way to French West Africa and were able to stumble ashore.

The were picked up by police who told them they were in Free French territory, given some boiled rice and put in a cage behind barbed wire for three months were the conditions were terrible.

They were eventually released and at last found their way to a British cruiser and eventually made their way home.

July 1943

FRENCH MAN SHOOTING
Boy charged with shooting Frenchman

A 13-YEAR-OLD boy who pleaded not guilty and reserved his defence was sent to trial at the next assizes by the magistrates at Cardiff Juvenile court charged with the manslaughter of Ange Matre Le Corre, a 42-year-old Free French seaman. Mr Leslie Owen, who prosecuted said about 11am on June 23, Le Corre was walking along Newport Road with a friend.

Le Corre was on the outside of the pavement and when they were passing the Cardiff Royal Infirmary there was a sound of an explosion and Le Corre fell to the ground exclaiming in French he had been wounded.

At the same time Police Constable Davies was cycling towards the city and was about 70 yards away. He went to Le Corre's assistance but Le Corre was dead.

Investigations were made, and as a result of information Detective Sergeants Bishop and Pugsley went to flats in Newport Road and entered by a ladder through a first-floor window where they found behind a curtain a service rifle, the barrel of which smelt of exploded powder.

A little later a boy entered the flat and was asked by the officers if he had been using the rifle and he replied he had often played with it.

He made the following statement which read: "I did fire the rifle sir. I did not know there was a bullet in it. I pointed the rifle out of the window. I pulled the trigger and I was surprised when it went off.

"I saw a man fall to the ground. I remember now, sir, putting a bullet in the rifle. When I played with it before I always had the safety catch down. I never intended to shoot anyone."

His father warned him of the danger of touching a rifle and told him not to interfere with his.

Mr Morgan Evans, for the lad, submitted that there was no case to answer.

The prosecution had to prove that the lad had the capacity of knowing that what he was doing was wrong.

April 1944

WELCH REGT

Cardiff to honour Welch Regiment

The Welch Regiment is to become, in effect, Cardiff's own regiment. It is rare and altogether appropriate distinction that the city council proposes to bestow at its next meeting on Monday next.

The Lord Mayor will move a resolution, the salient point of which is: "That in recognition of the glorious record of the Welch Regiment and of the very long association and cordial relations which have existed between the corporation and the regiment, the council do confer on the regiment the privilege, honour and distinction of marching through the streets of the City of Cardiff on all ceremonial occasions with bayonets fixed, colours flying and bands playing."

July 1945

"JERKS" BY RADIO!

Patients at the Ministry of Pensions hospital at Rookwood, near Cardiff, above, will soon be doing physical exercises by wireless. As in other hospitals, each bed is fitted up with a set of headphones, controlled by a master radio.

Now in addition to the BBC programmes, bed-ridden patients will be able to do simple exercises on instructions given over the microphone by their gym instructor. Medical officers will be in the wards at the time to see how the patients react.

January 1946

CARDIFF FEWER DRUNKS

Cardiff had fewer 'drunks'

There were 68 fewer "drunks" in Cardiff in the previous year, said Chief Constable Mr James A. Wilson at the Cardiff Brewster Sessions today.

The reasons for this he gave are:

1. The shortage of "spirituous liquors" and the prices charged for them.

2. Less people receiving high wages in the munitions industry and

3. The return home of American troops with a consequent lessening of spending power.

March 1946

IRISH TEAM LOST WAY

Irish team lost on way to Cardiff

The journey here of the Irish rugby team to meet Wales in the international at Arms Park, Cardiff, tomorrow was tinged with adventure with officials and players only reaching Cardiff in the early hours of this morning.

After having a smooth sea crossing from Ireland yesterday, their journey lay by road. The team travelled from Chester by private bus and were lost on no fewer than 11 occasions.

Soon after leaving Chester they found themselves ice-bound and for some time only the slowest progress could be made.

Then their bus broke down and after some delay members of the team alighted and realised the driver had disappeared.

As one of the players said, "It was not pleasant standing on a road in a strange country, with snow-capped mountains on either side of you."

When the driver eventually returned he said he had gone by car to find a spanner.

That was not the end of the story, for another stop was made after 15 minutes when the party found itself in a cul-de-sac, the driver taking another wrong turning.

This morning some of them played a round of golf, while others went for a walk around Penarth, where they are quartered. Dr Jack Matthews, the Cardiff captain, whose professional duties at the moment lie in Penarth was an early caller to the Irish headquarters.

January 1946

GI BRIDES

They didn't mind the grey skies

To many people, Cardiff general station was a dreary and miserable place this morning, but winds and rain could not damp the spirit of Cardiff's second contingent of GI brides who were about to

take the first steps towards re-union with their American husbands.

These brides, six in number, had received urgent telegrams from the American authorities telling them to

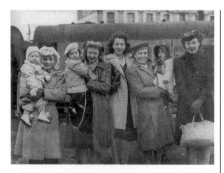

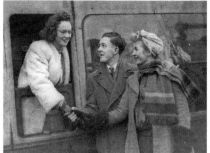

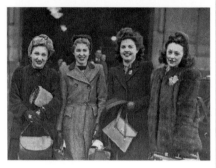

report to Salisbury Transit Camp – the girls are hoping that they will travel to the States on the Queen Mary, which should be ready to commence its journey on Sunday.

Pretty fair-haired Barbara Heath, aged 24, of Piercefield Place, Heath, Cardiff, pictured below, married to an already demobbed GI and who has an 18-month-old daughter, is on her way to Stega, Illinois.

Sadie Zajkowski, of Lansdowne Avenue, Cardiff, also pictured below, is the wife of a staff sergeant and was travelling to Long Island.

A late arrival on the platform was Lucille Esch, a 20-year-old bride from Neath, whose husband intends to enter the ministry. Lucille will probably also go to college in Fort Worth, Texas, to follow up her studies in connection with nursing.

March 1946

ELY HOUSING

They're in – but had to leave their chickens

Proudest persons in Cardiff today are Mr and Mrs Henn – and they certainly have something to cackle about.

Together with their child they are the first occupiers of the first of the city's new permanent houses at Red House Crescent, Ely.

Their only complaint is that they had to leave their chickens in the back garden of their former dwelling in their haste to take advantage of their good fortune.

They were happy in their new home despite the coldness of the rooms, the grey and damp of a new building, and the task of "getting straight."

The new houses are of the conventional five-roomed type with two living rooms on the ground floor and three bedrooms with wardrobe space built into each room.

November 1946

RAY MILLAND VISIT
Hollywood star in Cardiff

At an early hour, long before most people in Cardiff were awake, Ray Milland, Neath-born Hollywood film star, got into a small car and drove to the village of Tongwynlais, there to see the public house where he had his first drink and where formerly lived Olwen, his youthful sweetheart.

"I was only a boy at the time," he told a South Wales Echo reporter, "but, I have been looking forward for years to stealing off on my own and seeing the old spots.

"I don't remember much about Olwen and couldn't tell you her surname, but she was pretty, all right, and I'll never forget her.

"From Tongwynlais I drove to Taffs Well and saw another pub I used to drink in before I ever thought of getting to Hollywood."

He also said he looked for the shop of Davies the Tailor, not because Davies made his first pair of trousers "but he used to have a very pretty daughter".

Mrs Ray Milland was not upset by this frankness of her husband.

"Everybody has to have a first sweet-heart," she said. "And Ray is no exception."

Ray confessed that his greatest "kick" this morning was the breakfast he had at the Angel Hotel. "It was a pound and a half of lava bread brought up from Neath," he said. "I love it and ate the lot. We can't get it in the States."

He went on: "Cardiff is the neatest city I have seen since coming over here. And the people are quite the nicest of any place you like to mention – very understanding and really friendly.

"I would like to spend a little more time here this time, but I hope to return next month from the Continent, and intend to visit Neath, my home town.

"Yes I'm nervous about all this – even in Cardiff," he confessed, "but it's not because of the crowds. I suppose it's due to the people here being different towards one from what I experienced in London at the Command performance. That was terrible."

He was to leave Cardiff for London the next day, then fly on to Cannes where he was to receive the premier film award from the French President for his performance in The Lost Weekend.

May 1947

EMPIRE CINEMA

The sky's the limit!

Deanna Durbin's singing literally took the roof off the Empire Cinema on Monday night.

At precisely 8.19pm, just as Idris and the organ were "coming up out of the floor", another mechanical apparition was observed in the roof.

The entire central glass dome slid back to reveal blue skies and let in a welcome breath of fresh air.

Filmgoers were surprised, one saying: "I had seen cinemas with sliding roofs in the Middle East, but thought this was the first time such a thing had happened in Cardiff."

Mr Hicks, the house manager, explained that the sliding roof had been a feature of the building for years, and almost daily the air in the theatre is purified by "taking off the roof".

The dome, which is on wheels, is hauled with the greatest of ease along two rails by steel wires running over pulleys.

Around it scores of incendiaries were dropped onto the concrete roof during Cardiff's nights of blitz but, remarkably, not one touched the dome.

Hitler tried hard....but it took Miss Durbin and a heatwave to make a hole in the roof.

May 1947

HE WANTS A WIFE

If he is to be taken seriously, Clayton Stewart, of Burlington, Prince Edward Island, Canada, wants a wife.

To communicate his desire to anyone one of the opposite sex who may be interested, he has chosen a novel course of writing his proposal on a piece of stiff paper and enclosing it in a bag of potatoes, presumably raised on his farm.

After its passage across the Atlantic and its acceptance by a firm of importers in Cardiff's Custom House Street, that 100lb bag of potatoes reached James Tyler, a greengrocer, of Whitchurch Road Cathays, Cardiff.

When the bag was opened for retail, Mr Tyler discovered the message, written in pencil: "Wanted, a nice wife, between 40 and 50; lots of money; good place to live; good farm.

"Please answer, or, if male gets it, please give to a lady."

October 1947

TEN BOB FINE

"'Wot, only 10 bob!'"

The old soldier limped into the dock at Cardiff Magistrates court, waved his cap and bade the bench a cheery "good morning".

He was Morgan Jones, age 52, of no fixed abode, whom the manager of a Cardiff store saw walking down the street with a pair of trousers in his hand bearing a label, "Good Quality – 13/1½"

"But you didn't see me take 'em from outside the shop, did you." asked Mr Morgan calmly.

"I picked them up from the pavement. That's corporation property, isn't it, not yours?"

The store manager admitted he did not own the pavement.

Morgan gave a fine dramatic out-burst when police were giving evidence.

"You're always searching me in the street," he shouted. "It's worse than Belsen; that old sergeant kicked me in the shins just because I was picking up fag-ends."

He chewed the end of his tattered tartan scarf and muttered: "Duw it's as bad as a court-martial."

When the bench fined him 10s, to be paid within the month, Morgan shouted, flabbergasted, "Wot, only 10 bob! You'll have it tomorrow."

September 1947

CARDIFF CASTLE
Marquis makes it Cardiff's Castle

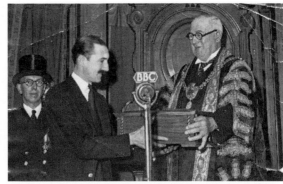
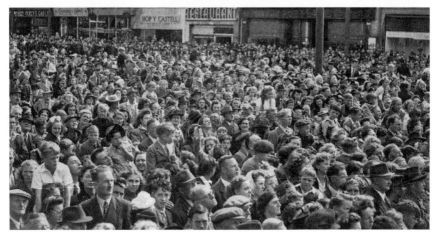

Cardiff yesterday took over the castle from which it sprang. The day was acclaimed as comparable with the historic day in 1839, when there was opened the West Dock, built by the third Marquis, and first of the docks on which the port's greatness was founded.

Yesterday the fifth Marquis built the keystone into commercial, cultural, and aesthetic fabric of the city, when he gave the Castle and its grounds to the city for ever.

For some hours before the Marquis of Bute formally handed over the key of the castle to the Lord Mayor (Alderman George J Ferguson) at the main gate people began to arrive in hundreds and take up their position in sunny Duke Street and Kingsway.

At the same time castle employees many of whom families had been Bute servants for generations, looked over the grey walls of the castle.

Representatives of the new generation to whom the gift will mean so much stood 250 strong outside the gates and sang. They were schoolchildren of the city. Their sweet young voices could be heard above the roar of the city traffic.

Led by Dr H.C. Hind, it was as if they raised their voices in gratitude to the Fifth Marquis of Bute, whose generosity spells health and inspiration in the years to come.

The historic ceremony of the presentation of the castle and the grounds, with Sophia Gardens, began at 10.30am, when the Lord Mayor and Lady Mayoress and received the Marquis and Marchioness and their party in the Lord Mayor's Parlour.

Half-an-hour later the city council held a special meeting, when the Lord Mayor said: "This gift is the culminating act of many which will forever associate with distinction the name of Crichton-Stuart with that of Cardiff."

The Marquis, responding to expressions of thanks, said: "I have come today

with no speech prepared because I feel that in doing so I will be speaking to you straight from the heart. I am overwhelmed with the kind terms in which you referred to me.

"Naturally, on a day like this, I have certain regrets, but I am not leaving the home of my ancestors entirely. I have no intention of severing connections between my family and this great city.

"I feel rather overwhelmed at the response you have all given me. I do not know how to thank you, but I feel I would like to say that I feel great satisfaction in handing to this city the castle from which it sprang."

Earlier, the Lord Mayor had proposed the following motion of thanks and appreciation:

(1) That the members of the council express to the Most Honourable John Crichton-Stuart, Fifth Marquis of Bute, Baron Cardiff, their deep sense of gratitude for this munificent gift of Cardiff Castle and its grounds (with Sophia Gardens) to the citizens of the City of Cardiff.

This Gift is the culminating act of many which will forever associate with distinction the name of Crichton-Stuart with that of Cardiff.

The council recall on this historic occasion the development of the city and the grant of its early charters from the 12th century by the Lords Marcher of Cardiff. They recall the creation of John, First Marquis of Bute, as Baron Cardiff in 1776, and the beneficent influence since exercised by each successive holder of this distinguished title in the development of the city.

In particular they recall those great acts of vision and enterprise through the 19th and early 20th century by the forebears of the present Marquis of Bute in constructing and establishing the Bute Docks upon which the present size, prosperity

and importance of the City of Cardiff is founded.

The gift of Cardiff Castle and its grounds, with their Roman and Norman associations, sets a princely seal upon these acts of enlightened enterprise and is strikingly in keeping with that identity of interest between the castle and the city traditionally maintained by the Lords of Cardiff.

It will ensure for the people of Cardiff unsurpassed amenities for health, exercise and inspiration in the heart of the city and will, with Cathays Park, provide a civic setting of nobility unequalled in Great Britain.

This gift will perpetuate the name and memory of the Fifth Marquis in the hearts of the present citizens of Cardiff and of a generation of citizens yet unborn.

(2) That this motion be engrossed on vellum, sealed with the Corporate Seal, and placed in a suitable casket to be presented to the most honourable John Crichton-Stuart, Fifth Marquis of Bute, by the Lord Mayor on behalf of the City Council.

Seconding the motion, Councillor George Williams said, "It is a gift, my Lord, which will be freehold for all time to enable people young and old, to enjoy the amenities of this beautiful centre. London has its Hyde Park. I want to see Cardiff have its Bute Park.

"That my Lord Mayor, to me will be the crowning glory of the City of Cardiff. I wonder whether I could have summoned enough courage to take such a great decision, to sever a heritage of more than 2,000 years, a heritage of my own forefathers.

"But the Marquis is a Cardiff citizen. He is handing this to us as one of the people. I believe the Marquis has placed Cardiff in the forefront of the cities of the world. On behalf of the citizens of Cardiff I thanks you from the bottom of my heart – and from the citizens of Wales, 'Diolch yn fawr."

Supporting, Alderman A.E. Gough said the castle grounds and historic buildings had been preserved by the ancestors of the noble Marquis; otherwise all lands might have gone to the modern vandal, the speculative builder, or, perhaps to the more ruthless despoiler, the builder of arterial roads.

"But it has been saved and the people rejoice," he added.

The motion was then put by the Town Clerk, was received with the enthusiastic cries of "Aye" from the robed aldermen and councillors.

The Marquis of Bute then received from the Lord Mayor a temporary casket of oak containing a vellum carrying the council's motion.

Later, in procession, the Lord Mayor, with the mace bearers, the Recorder of Cardiff (Mr H Glyn Jones, K.C.), the Town Clerk (Mr S Tapper Jones) and members of the city council made their way to the main gates of Cardiff Castle, headed by the band of the Royal Welch Fusiliers.

As the last of the procession took its place near the drawbridge the crowd surged forward and blocked the thoroughfare.

After the Marquis of Bute had received the Lord Mayor the crowd led by the school children's choir, sang "Hen Wlad fy Nhadau" and "God Save The King."

With the handing over of the key the full significance of the occasion really became apparent to the people. The first person to salute the flag of the City of Cardiff as it was hoisted over the Norman Keep to the accompaniment of maroons and three fighter aeroplanes roaring overhead was the Marquis himself. Cardiff Castle had become *Cardiff's Castle.*

September 1947

ALDERMAN "HOT UNDER THE COLLAR"

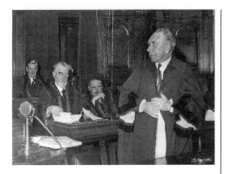

A special meeting of the Cardiff City Council opened on a note of discord.

As proceedings were about to begin Alderman TG Kerrigan (Socialist) rose and protested against the condition of his aldermanic gown, which was without a fur collar.

"I came here as a member of the Cardiff City Council, and an alderman, and if the Cardiff City Council cannot array its representatives in better garb than this," he said, pulling the lapels of his gown apart, "I think something should be done about it, and personally, I am disgusted, and will take it off."

Suiting the action to the word, the alderman then dis robed and placed the gown on the back of a nearby chair, where it still remained after the council chamber had emptied.

Alderman Kerrigan said later: "It appeared that the Lord Mayor had already given a spare robe to another alderman and it was very unfortunate that as all the aldermen turned up for the meeting the one I had was the only one left.

"I merely wanted to be treated in the same manner as my colleagues."

July 1948

CITY FREEDOM, HERO'S WELCOME FOR CHURCHILL

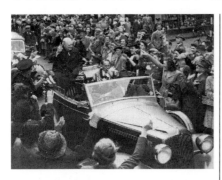

Mr Churchill had a "conquering hero" reception from big crowds when he

arrived at Cardiff yesterday to receive the freedom of the city.

He flew from Bristol, where earlier in the day he visited the university as Chancellor to present honorary degrees to six of the Vice-chancellors of Empire universities who have met in Bristol this week.

Mr Churchill arrived in Cardiff earlier than was announced and was taken to the Mansion House in a closed car, where he lunched privately with the Lord Mayor and Lady Mayoress and Mrs R G

Robinson before making the journey to the City hall in an open car cheered by the thousands of people along the route.

Those who could attend the ceremony waited patiently until it was all over and cheered the city's newest freeman as he made a short tour of the streets on his way to catch his aeroplane for London.

On arrival at the City hall Mr Churchill went first to the Lord Mayor's Parlour, where members and officials of the council were introduced to him, as well as the Mayors and Mayoresses of Swansea and Newport.

As he left the Mansion House on his way to the City hall Mr Churchill paused for a word with patients at the Prince of Wales Orthopaedic Hospital, whose beds had been wheeled out on to the pavement. Mothers held up their children to him and while people clambered over his car others touched the lapels of his coat and said, "Thanks for all you have done for us."

Leaving his car at the entrance of the City hall, he spoke to a party of Danish youths who waved flags to greet him.

On his return journey from the City hall to the airport Mr Churchill stood up in his car and acknowledged the cheers by giving the "V" sign and waving his hat to the crowd.

He passed at one point, close to an old lady in a bath-chair, who was clearly thrilled at having such a good view of him. One little girl on her father's shoulders smiled happily as he waved to her.

Firemen perched on a fire engine in Queen Street had almost a "bird's eye view" of the procession.

Nurses and children from the Cardiff Royal Infirmary were given a special wave from Mr Churchill.

As the cars moved slowly through Broadway a bulldog on the pavement started barking fiercely. One kiddie staggered under the weight of a Union Jack four times his size.

In the Splott area there were many men in shirtsleeves and women in aprons among the spectators.

At the airport the Lord Mayor and the Lady Mayoress, Mr W J Price (the Chief Constable), Mr S Tapper Jones (the town clerk) and others shook hands with Mr Churchill. As he was boarding the aeroplane he was handed two copies of the South Wales Echo, which he smilingly acknowledged.

A last-minute sensation almost marred the day. The aeroplane was taxi-ing when police and attendants made a 50-yard run to drag some boys from underneath the wings of the aeroplane.

After stopping the aeroplane to allow them to be rescued from danger the pilot made a perfect take-off.

October 1948

CARDIFF BOY A HOLLYWOOD FILM STAR OVERNIGHT

Former Cardiff schoolboy and cinema club marshal, Ian Vye-Parminter, has become a Hollywood film star overnight.

With his parents, Mr and Mrs Thomas S Vye-Parminter, 14-year-old Ian flew out to British Columbia last November to make a new home in New Westminster, where Mr Vye-Parminter had found a new job.

Young Vye-Parminter was for many months senior traffic marshal in Cardiff

for the Odeon National Cinema Club. Last month he signed a contract with Metro-Goldwyn-Mayer, who now have an option on his services for 6½ years.

He has been given his first screen role, the longest part in The Secret Garden, being made in Culver City, in which he will appear as Dickon with Margaret O'Brien and Edmund Gwenn.

Fred Wilcox, MCM director, was looking for an English boy with a Yorkshire accent. Ian was born in a county of broad acres and his father and mother are native of Leeds. So it was that Ian, right, in company with four other boys, was given a script-learning test, and ultimately got the job.

All this happened because Mr Vye-Parminter read a newspaper paragraph stating that Mr Wilcox was pursuing in Vancouver his quest for a suitable boy to play the part of Dickon in the company's next production.

Mr Vye-Parminter telephoned, spoke to Mrs Wilcox, and the date was fixed, Ian was given 14 pages of script from the film and a few days later had a screen test. The next news the family had was by way of a telephone call from Culver City asking Ian to be flown down to Hollywood.

Novemeber 1948

MEDAL FOR HEROIC CARDIFF PC KENNETH FARROW

The King has awarded the Albert Medal to Constable Kenneth Farrow, above, of the Cardiff City Police Force, in recognition of his gallantry in attempting to rescue a four-year-old boy from drowning in the feeder at Pembroke Terrace, Cardiff.

The award was announced in the London Gazette last night. Constable Farrow lives at 109 Clive Road, Canton, Cardiff.

The incident occurred at about 7pm when Constable Farrow was informed that a child had fallen in the feeder.

Constable Farrow ran to the place, dived into the feeder and swam underneath a long concrete covering for about 180 yards in search of the child. The feeder was uncovered at the spot where the child fell in and the speed of the current was about 6mph. Headroom at the end of the concrete covering was 2ft 2in decreasing to six inches and the water, black with a considerable amount of mud or silt at the bottom. It was not possible to stand up with head above water level.

Although the child's body was not recovered till later, Constable Farrow greatly exhausted himself in the search and in the ordeal of making his way back against the current, with very little facility for obtaining a proper handgrip.

February 1950

CARDIFF STUDENTS IN COURT
Welsh students' 'game' ends in court

AN annual rugby match between the mining departments of Birmingham University and Cardiff University College, celebrated afterwards with a party in a Birmingham hotel, led to the appearance of six of the Welsh students before Birmingham magistrates.

It was alleged by the police that while some 30 students were singing Welsh national songs in New Street, six of them played football with a Belisha beacon.

The six defendants were each fined 15s and ordered to pay 8s 4d compensation for being drunk and disorderly and doing wilful damage to a Belisha beacon.

A police sergeant said that he saw a crowd, 20-30 strong, walking up New Street towards Victoria Square. They were singing Welsh national songs and were spread across the pavement.

Outside the Theatre Royal, the six defendants detached themselves from the main body, uprooted a Belisha beacon standard and after detaching the orange globe, played football with it in the middle of the road.

When they saw the police they ran with the others and when stopped were shouting things like "Up Mr Bevan," and "Long live Ebbw Vale."

The constable said other things were shouted at the officers including, "Aren't you Birmingham police wonderful?" and "Remember me to 49."

February 1950

HELICOPTER
Wales leads the world in helicopter travel

 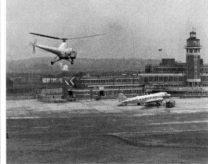

WHAT is believed to be the first sched-
uled passenger helicopter service in the
world will come into operation on June 1
between Cardiff and Liverpool.

Mr Peter Masefield, chief executive
officer of British European Airways, told
the Welsh Advisory Council for Civil
Aviation in Cardiff today: "This is some-
thing completely new.

"I might also say revolutionary, even
the Americans have not done this. North-

South air line was inaugurated last spring
as an experiment, but was discontinued
in the autumn because of operational
difficulties."

Since then talks have been in progress
for a resumption of the service and the
helicopter scheme is the answer.

Three passengers can be accommo-
dated on each trip and the journey taking
one hour and 45 minutes. Single fares are:
Cardiff-Liverpool £3 10s, return £5 10s.

February 1950

LAST TRAM
Cardiff Farewell to Last Tram

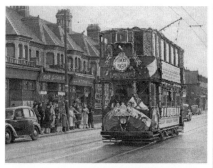

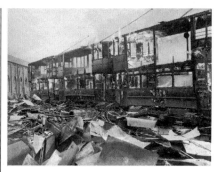

In 1902, Mr T A Bickel stood outside
his father's fishmonger's shop in Queen

Street and watched the first tramcar gaily
bedecked with bunting and flags ride
through the streets of the town.

Today Mr Bickel again stood outside
his fishmonger's shop, in St Mary Street
this time, and watched the farewell trip
of "The Veteran," Cardiff's brightly deco-
rated last tram.

"I was only a schoolboy at the time," he
told a South Wales Echo reporter today.

"but I can remember the councillors
and the mayor – Cardiff was only a town in
those days – making the first trip together."

It was considered a great step in the progress of Cardiff transport because the electric trams replaced

the horse-drawn vehicle and was the first move in the direction of mechanisation, Mr Bickel, however said that the enthusiasm which greeted the first tram was mild compared with that of Cardiff citizens and "The Veteran" today.

Kiddies chased the tram through the back streets of Adamsdown, chanting the verse printed on the outside.

Goodbye, my friends, this is the end.
I've travelled miles and miles,
And watched your faces through the years
Show anger, tears and smiles.
Although you've criticised my looks
And said I was too slow
I got you there and brought you back,
Through rain and sleet and snow.

This was the verse surrounded by bunting and flags

The tram was crowded on nearly every journey between St Mary Street an Whitchurch Road, many taking the special souvenir ticket for the sake of sentiment. Some bought four or six tickets – for remembrance.

Three veterans of Cardiff transport were in charge of the tram on this special occasion. Driver M Williams has 38 years to his credit, and conductor, J Brooks (No. 20) also has 38 years. The other conductor W Holden (No. 106), has given 42 years service – he is due to retire in December this year.

Tonight, the Lord Mayor of Cardiff (Alderman T J Kerrigan) and city councillors will make a special journey between the two termini, and then "The Veteran" will make her final trip to the main tram depot.

During the early part of the day the tram is not being lighted, but for its last few journeys this evening coloured light bulbs are being fitted. When darkness falls, and the members of the Cardiff City Council take their places for the final journey from Whitchurch Road to Roath depot, the old tram will be a blaze of lights.

She will be preceded by the pipe band of a Cardiff Scottish troop of scouts.

The old order changeth. Its Vale, the Veteran.

March 1951

NOVELLO DIES

Brilliant Ivor Novello, Cardiff-born actor-manager and composer, who won fame with his musical plays and songs, died in London early today after a sudden attack of thrombosis. He was 58.

Ivor Norvello was in the theatre until the last, having played as usual in "King's Rhapsody" at the Palace Theatre last night.

He seemed perfectly well and had supper at his flat with manager Tom Arnold, who presented his plays.

He complained of a twinge in his side, but did not seem very ill. At 2 am he became very ill, his doctor was summoned, and he died peacefully in his flat a few minutes later.

Tonight's performance at the Palace Theatre will

not take place, but performances will be resumed tomorrow with Mr John Palmer, Mr Novello's understudy, taking his part.

Gay songs and sad lilting melodies from half a dozen musical plays are the world's memory of Ivor Novello.

It was his song "Keep The Home Fires Burning," that captured the spirit of the marching thousands who left Britain's shores for France 1914-1918.

Ivor Novello was inspired by his mother, Madame Clara Novello Davies, who won fame as a pioneer of women's ensemble singing, and it was her inspiration that lead him to write this song. It earned him £16,000.

Success did not come easily to the handsome young man. He studied composition under Dr Brewer after being edu-cated at Magdalen College School, Oxford to which he won a choral scholarship.

An early venture was a provincial tour which made him a little money. His name first became a by-word in London's thea-tre land in 1924 when his thriller "The Rat" achieved great success.

In the next ten years he wrote a suc-cession of smart box office comedies and then, in the Silver Jubilee year, his first big musical. This was the Drury Lane and the play was "Glamourous Nights."

This success was consolidated with many more hits – among them "Careless Rapture," "Crest of the Wave," and "The Dancing Years" songs from which are remembered by millions.

Of all his musical plays the "Dancing Years" is probably his best known. Ivor Novello regarded this as his finest show.

April 1951

POLICE WHISTLE

With a crowd of other onlookers, Mrs Linda Stanworth, of Byron Street, Cardiff stood watching a fierce struggle between Police constable Symes and 27-year-old Frederick Lovell.

Suddenly Police constable Symes's whistle came flying through the air in Mrs Stanworth's direction.

She ducked, but not fast enough and the whistle hit her and fell to the ground at her feet.

She picked it up and looked at it. "Blow it, blow it" urged the crowd. And Mrs Stanworth blew, bringing assistance to the attacked constable.

Lovell was sent to prison for six months.

April 1951

CARDIFF CENSUS TROUBLE
Census workers' Cardiff troubles

The unfamiliar title "head of the house-hold" is making the chests of many Cardiff fathers swell with pride as over 200 enumerators continue to saturate the city with census forms.

Although the public are cooperating "magnificently" a few misunderstandings have arisen, Mr L D Rumbelow, Cardiff registrar of Births and Deaths, told the South Wales Echo.

"Some people think the census is a political stunt, and say they are fed up with filling in forms," he explained. The enumerators are doing their best to enlighten them."

Old people who think they have to give details of their marriages are causing other snags.

"It is hard to convince them that only married couples under 50 have to give any details" said Mr Rumbelow.

"Many housewives look suspicious when asked, 'How many rooms have you in this house?' This is the only question which is answered verbally by the householder and written down by the census-taker.

"They seem to think that if they give the answer they will immediately have people billeted on them," said Mr Rumbelow.

But put your fears at rest. Only living rooms are counted, and the census is secret – so secret that not even Government departments or the police are allowed any information.

There is one thing different about the census in Wales. You have to say whether you speak English, or Welsh, or both, and you can insist on filling in the form in Welsh.

Hardest worked census-takers in Cardiff are those working in the Docks districts. They have to talk to people of many nationalities.

Here are a few tips on how to help the census-takers:

Do not be too reserved and say nothing, and don't be too talkative and give him the family history. Just answer the questions and take his advice.

Don't be offended if you offer him a cup of tea and he refuses. He has not got much time.

April 1951

CARDIFF IS CAPITAL CITY ELECT

No flags flew triumphantly over Cardiff's civic centre today to celebrate the city's designation as the capital-elect of Wales.

The sun shone a little brighter, the Lord Mayor was a little busier. Otherwise it was business as usual in the city that was yesterday described as a "worthy Welsh capital," and by a Welshman too.

Mr Huw T Edwards, chairman of the council for Wales and Monmouthshire, was the Welshman who, with the backing of the council, announced to the world that Cardiff should, at last, be recognised as chief city in the Principality.

The council's recommendation, which eliminates Aberystwyth, Caernarvon and Llandrindod Wells as the other contenders, is to go to the Government.

Mr Attlee, who a year ago declined to promote Cardiff to capital status on a petition from the city, is expected to agree this time. Then perhaps Cardiff will put out more flags.

April 1951

MYSTERY SPANISH MAIDENS

Mantilla maidens bring city a mystery

Who are the Spanish women who are making Cardiff seem like a little bit of Barcelona? The mystery of the señoritas could not be answered by authorities today.

Old Spanish residents of Cardiff say that they have noticed numbers of young dark-skinned girls gossiping in Spanish as they shop in twos and threes. The girls are usually in Cardiff's main streets on Tuesdays and Saturdays, they say.

A Spanish woman who has lived in Cardiff since 1910, Mrs Goita Pepita, 49-year-old proprietress of a restaurant in West Bute Street told the Echo: "We know nearly all the Spaniards in Cardiff, but we do not know these girls. From what we gather most of them seem to live in Grangetown."

Apart from the unknown senoritas, over 100 have arrived in South Wales in the past three months as sponsored immigrants.

April 1951

SPEEDWAY

20,000 see speedway thrills

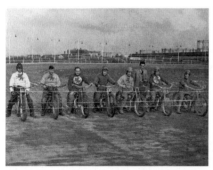

Though Cardiff Dragons were beaten 54 points to 52 by Rayleigh Rockets in the National Trophy competition last night, the grand opening of the Cardiff speedway track at the Penarth Road stadium was a great success.

The fine weather enticed a crowd which must have been in the region of 20,000, and, judging from the cheers and general excitement worked up during the evening's entertainment, the Cardiff public might well have decided that speedway has come to stay for quite a while yet.

A new sport is always difficult to put over, but some great exhibitions of hard riding by members of both teams helped make the task of the promoters a great deal easier.

Certainly it seems safe to say that Cardiff folk and others from much further afield have on their initiation caught on to speedway enthusiastically.

November 1951

EXPLOSION PRISON

Man blown through roof in gas explosion

Three people were injured, two of them seriously when a gas explosion "shattered to matchwood" a room in the women's wing of Cardiff Prison.

The most seriously injured was a prisoner named Kelly. He is understood to have been blown through the roof of the building and suffered a broken leg, severe head injuries and burns. He is detained at Cardiff Royal Infirmary.

The explosion occurred in the committee room of the woman's prison. A new gas fire was installed in the room and the matron had complained of a smell of gas which may have been caused by a leak from the fire.

The assistant engineer went to examine the fire with a prisoner employed by him and while trying to detect the leak, a terrible explosion occurred blowing out all the windows and door to the room, smashing furniture to matchwood and the floor collapsed.

People in the neighbourhood reported hearing a loud explosion, which shook window frames.

March 1952

UGLY CITY SITE

Ugly sight greets travellers

Cardiff's white elephant, the Wood Street site, has been cropping up regularly in the corporation's agendas ever since the clearance scheme of Temperance town was decided upon in 1933.

The grandiose plan for a huge sports arena and public hall under one roof was finally abandoned last year. Now the corporation are left with three open parking areas, dusty in summer and pitted with deep rain-water pools in winter, which up to last year had cost the ratepayer £60,000.

Yesterday the corporation transport committee made a cautious contribution to one proposal to begin clearing up the eyesore in the centre of the city when they approved on principle the plan for a central bus station on part of the site.

Such difficulties as refusals by the Ministry of Works to grant building licences have wrecked development projects in the past. But how long is the site to remain a thorn in the side for the city planners?

For thousands of travellers daily arriving by train and walking through the wasteland the site is the worst possible introduction to the city which claims premier status in Wales.

June 1952

SKID KIDS

Dragons' manager keeping eye on the 'Skid Kids'

THE "Skid Kid" cycle speedway craze which is attracting so much attention over the country and has recently taken hold of local youngsters is not going unnoticed by Cardiff speedway authorities.

Dragon manager Bill Dutton, in fact, hopes to do something about it himself very soon.

Mr Dutton, who was at one time a member of the control board for cycle speedway, is very keen to encourage these up-and-coming starlets.

Some of the best senior speedway men in the country were apprenticed in the rough and tumble of the cinder "Skid Kid" school and Wales may even produce a few "home-grown" riders to take their place in Cardiff Dragon teams of the future.

"Our boys need encouraging and who knows what talent we have here undeveloped."

September 1952

MATTAN HANGED

Woman weeps as Somali is hanged

Almost within a stone's throw of the house in which he lived in Cardiff, Mahmoud Hussein Mattan was executed today for the murder of a Jewish shopkeeper at Cardiff Docks.

Mattan, a 29-year-old Somali lived in Davis Street, less than 200 yards from the entrance to Cardiff Prison, where, just after nine am today, in drizzling rain a prison officer hung the notices informing the public that judgement of death on Mattan had been carried out.

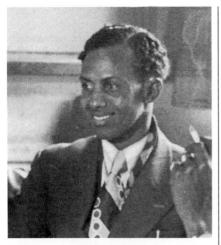

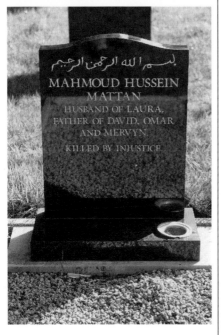

بسم الله الرحمن الرحيم

MAHMOUD HUSSEIN
MATTAN
HUSBAND OF LAURA,
FATHER OF DAVID, OMAR
AND MERVYN.
KILLED BY INJUSTICE

An hour before the execution took place a woman dressed in a blue raincoat, her head covered by a head scarf, was seen weeping outside the entrance to the prison. She was later joined by another woman and at 8. 20 am, they left.

There was a small group of people outside the main entrance to the prison at nine o'clock including several coloured persons.

They read the notices which were hung outside shortly afterwards and slowly dispersed. Throughout the morning workmen and passers-by stopped to read the notification.

Mattan was convicted at Glamorgan Assizes on July 24 of the murder of 41-year-old Lily Volpert and was sentenced to death. His appeal was dismissed by the Court of Criminal Appeal and a few days ago the Home Secretary announced he could find no grounds on which to interfere with the course of justice.

Miss Volpert was found lying in her shop in Bute Street with her throat cut. Mattan, known in Cardiff Dockland area as the "shadow" because of the silent way in which he moved was arrested more than a week later.

At his trial his counsel, Mt T E Rhys-Roberts, described Mattan as "this half child of nature, a semi-civilised savage."

At the inquest conducted by Cardiff City Coroner (Mr Gerald Tudor) at the prison the jury returned a verdict of "Death from judicial execution."

The governor (Col W W Beak) said the execution was carried out without a hitch.

Footnote : Mattan's conviction was quashed 45 years later on 24 February 1998, his case being the first to be referred to the Court of Appeal by the newly formed Criminal Cases Review Commission. He was the last person to be hanged at the prison.

February 1952

BLOWN OFF BIKE

Cardiff workman blown off cycle

Sparks from a street lamp being switched off are believed to have caused gas to explode in the mains beneath Broadway, Cardiff.

The blast shattered windows, blew a man off his bicycle and hurled paving stones to the opposite side of the street.

Two explosions almost simultaneous occurred at two manholes about 50 yards apart.

"I thought the balloon had gone up again," was the comment of Mr E Thomas as he swept broken glass down his front path.

"I came out and found big chunks of pavement lying yards away. It was a real wreck.

"Some of the stones were blown across the road where a bedroom window was broken by the blast.

In the bedroom was three-year-old Linda Keohane, but fortunately the flying glass missed her. "It was a miracle," her mother exclaimed with relief.

A grocer living nearly a 100 yards away said the room trembled and a clock he was holding jumped from his hand.

The only man injured was a cyclist who was thrown to the ground and cut his face. He was shaken, but continued on his way home after some attention at the home of Mr and Mrs Andrew James in Bertram Street.

June 1952

'NO WELSH' SAYS DANNY KAYE

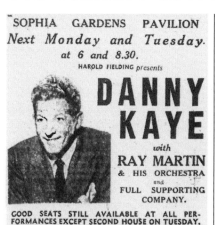

SOPHIA GARDENS PAVILION
Next Monday and Tuesday.
at 6 and 8.30.
HAROLD FIELDING *presents*

DANNY KAYE

with

RAY MARTIN
& HIS ORCHESTRA
and
FULL SUPPORTING
COMPANY.

GOOD SEATS STILL AVAILABLE AT ALL PER-
FORMANCES EXCEPT SECOND HOUSE ON TUESDAY.
APPLY: BOX OFFICE, SOPHIA GARDENS PAVILION.

IF anyone shouts "Sing us a Welsh song, Danny" from the audience at Sophia Gardens tonight, the irrepressible – but nevertheless sincere – Mr Kaye will answer: "I would very much like too, but don't know any Welsh."

After jigging and gagging his way through rehearsal today, Danny admitted he didn't know any Welsh songs with English words either.

"There will be no Welsh or Cardiff flavour in the show," Danny told the South Wales Echo.

"I don't mention the names of any local streets, the name of the local Lord Mayor or any product the town is famous for. I just don't believe in ingratiating myself with the audience."

May 1953

SWALLOWED RING

Not lost — just out of reach

A young man dashed into Cardiff Royal Infirmary during the weekend shouting excitedly, "I've swallowed a ring, what shall I do?"

He was calmed and taken to the X-ray department to have his inner-self exposed, when in rushed a number of irate females.

One was very near to tears and exclaimed hysterically, "Where is he, where is he? he's swallowed my engagement ring."

The X-ray bore out the young woman's statement for, sure enough, nestling in the young man's inside was a diamond ring.

Everyone could see it as plain as daylight on the X-ray plate but there was, of course, the problem of getting it back .

The medical profession decided to let nature take its course.

May 1953

BABY BANK

Baby's bounty — tomorrow's children will be lucky

Every baby born in Cardiff tomorrow will begin life with a bank balance.

Baby's bounty will be provided by Cardiff Savings Committee which unanimously decided this week to award each baby born in the city on Coronation day with a life savings certificate.

Awards will be made when the births have been confirmed by the Registrar.

July 1953

QUEEN FIRST VIST

Great welcome for Queen and Duke

So eager and fervent was the welcome accorded to the Queen on her first to Wales since her Coronation that the carefully timed programme went awry and the procession arrived at the City Hall in Cardiff a quarter of an hour behind schedule.

The route through the towns and valleys of South Wales was timed to the last minute, the mileage to a decimal point, and the speed to the last mile per hour, but the people who thronged the streets, valleys and hillsides to greet their Queen were not concerned with time.

They had waited, some of them for hours, and such was their enthusiasm of their welcome that the Royal timetable was upset and instead of arriving at the City Hall at noon the party arrived at 12.15.

As the Queen and the Duke crossed the city boundary at Llanishen on their way to Cardiff, a 21-gun Royal Salute was fired by HMS Apollo, berthed in Cardiff Docks.

At Cathays Park the crowds along the route included 10,300 children from Cardiff schools who were allocated positions.

The whole of the route into the centre of the city was lined by men and women from the Services and voluntary organisations.

Children waved Union Jacks and Welsh Dragons, paper streamers and coloured handkerchiefs. Hundreds of toddlers sat on the kerb stones and babies carried shoulder high waved tiny flags in their excitement of an event they could not comprehend.

October 1953

MONTY VISIT

Monty visit gives City soccer boost

FIELD Marshal Viscount Montgomery of Alamein enjoyed his visit to Cardiff over the weekend and said so when he lunched on Sunday in Cardiff Castle with the Lord Mayor and Lady Mayoress, Sir James and Lady Collins.

If a certain proportion of the city's inhabitants were given their way he would be here practically every other weekend – throughout the winter at least.

"I shook hands with the Cardiff team before the match and told them they had to win," he said. "And they did. Some miners sitting in front of me in the stand told me, 'if you'll come here every week we'll gladly pay your expenses'"

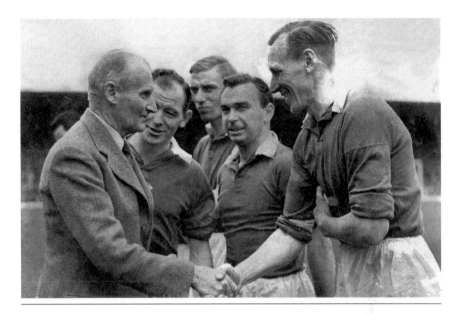

September 1953

RAILWAY NAILS

A BRIGHT idea brought four boys to Cardiff Juvenile court today.

They wanted some nails flattened to use on their fishing lines – so they stuck them under the wheels of the London express near Ely Station.

But their bright idea misfired. They were spotted by a police officer, who said he found the nails placed on the stretch of the main South Wales-London line.

Fining them five shillings each for trespassing on the railway, the chairman commented: "We don't think you are bad boys, but don't do this again. You might have been killed or injured."

September 1953

TRAMP

Tramp who 'died' by mistake

A 57-YEAR-OLD tramp, who three years ago was certified "as having died from natural causes," and seven months later turned up at Cardiff Magistrates' Court charged with begging, was found dead in the early hours on waste ground in front of Cardiff Central Station.

He was suffering from self-inflicted throat wounds.

In April 1949, the body of a bearded tramp was found on Leckwith. Police officers thought it to be well-known figure in the Cardiff streets, Ivor John Morris, of Penygraig.

Eventually his brother, William James Morris called at the mortuary, identified the body as that of his brother and it was buried under the name of Ivor John Morris, of no fixed address, born Appletree, Dinas, Rhondda.

On Saturday, December 13, Morris appeared before Cardiff magistrates charged with begging and perplexed police officers had the task of explaining that he had been "dead and buried since April". This earned Morris, a man of many similar convictions, an absolute discharge.

He later called at the South Wales Echo office to prove that he was not dead and told a reporter: "I am not a vagrant, just an ex-serviceman."

The problem facing the city police now is who did they bury in April 1949? Tonight the brother, Mr William Morris will be travelling again to the Cardiff mortuary to identify his brother.

October 1953

CENTRE OF CARDIFF
Where is the centre of Cardiff?

A DECISION over the weekend settled arguments as far as Londoners were concerned, with a point in Charing Cross being laid down officially as the centre of London.

The news got Cardiffians wondering where, in turn, was the centre of Cardiff? The City Hall? The Welsh National War Memorial? The site of the old City Hall in High Street?

Officials of the Royal Automobile Club in Cardiff were asked and their archives produced information fixing the city's distance from other points to the milestone near Cardiff Bridge.

But for route cards and tourist information the centre is shown as Cardiff Castle, which stands nearby and, of course, is a prominent landmark on the main London trunk road.

The South Wales group office of the Ordnance Survey also has the Castle as the official city centre on the new grid plans of Britain's built-up areas.

November 1953

CARDIFF v ALL BLACKS
Sid Judd headed the pack of trouble for the fourth All Blacks

Old timers can have their Wales – All Blacks epic of 1905: younger rugby fans rant and rave over the famous Wallabies-Barbarians tussle and the classic

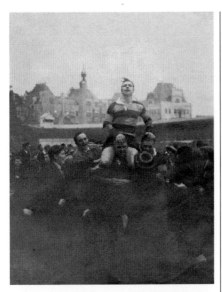

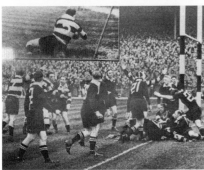

will linger in my memory as the daddy of them all (writes Dave Phillips).

For 80 minutes we saw the traditional skill and fire of what has rightly been termed "the greatest rugby club in the world," countered by the all-action enthusiasm of a determined All Blacks side who tried everything in their power to whittle down Cardiff's half-time lead of 5pts, in a storming grandstand view.

Maligned and under-estimated before the game as a "suspect pack," the Cardiff eight, well led by international Sid Judd, played like terriers against a larger and heavier eight, and seemed to increase in spirit and fervour towards the end rather than wilt as had been freely forecast.

To me, the turning point of the game came in the pulsating last 10 minutes when, throwing everything they had into a desperate attempt to save the day, the All Blacks camped on the Cardiff 25.

Then Geoff Beckingham, the "Blue and Blacks" hooker, won the strike twice against the New Zealand loose head to enable his backs to clear the hard-pressed line.

There were heroes in every position on the Cardiff side: Llewellyn, at full-back, Bleddyn Williams, Alun Thomas in defence, and the amazing Cliff Morgan, skilfully served by Rex Willis as the main threat to New Zealand equanimity.

Morgan was an enigma which the tourists failed to solve and his quick-fire scurries down the middle were the signal for "panic stations" every time he got under way.

But it was the pack which laid the foundations for this grand victory and beat the All Blacks at their own game.

Victory was assured for Cardiff in the first quarter of an hour when, after Judd had opened the scoring with a try which Rowlands converted, the right wing himself clinched the issue with a corner try which he just missed converting.

Jarden had previously reduced the arrears with a superlative penalty goal

Wales-New Zealand clash of 1935; but for nearly 60,000 wildly excited Welshmen Saturday's magnificent game at Cardiff Arms Park, in which Cardiff defeated the fourth New Zealand All Blacks by a goal and a try (8pts) to a penalty goal (3pts),

from fully 55 yards, but Cardiff fended all New Zealand's attempts to get on terms and held on grimly to that narrow five points lead to the end.

As Bleddyn Williams, the Cardiff skipper, said after: "That last 10 minutes seemed like hours."

July 1954

WHALE

Jonah is a 'Big' draw

On his journey around the world Jonah, the giant whale, has arrived in Wales.

Jonah has already travelled many thousands of miles throughout Europe and has attracted much attention everywhere.

Jonah is 65ft long and weighs 69 tons and was killed by a Norwegian whaleboat cruising off Trondheim, Norway, on September 1952.

As a rule whales are cut up aboard ship and turned into oil but Jonah was not destined for such a fate.

Mr Brokx, the manager of the exhibition, told the South Wales Echo that originally the whale was used for study, but so many people seemed interested in it that it was decided to take it on a world tour.

"We do not hope to gain from this trip.

"All we want to do is give people the chance to see the whale," he said.

Jonah rests on the back of a huge lorry, claimed to be the longest in the world.

January 1955

GYPSY QUEEN LYDIA

Queen Lydia pleads in vain

Led by "Queen Lydia Lee," the gypsies of Leckwith Common came to Cardiff Magistrates Court again today to face nearly 300 summonses for keeping caravans and tents on the common.

"Queen Lydia" appealed for her people to be given a place in which to live in peace when asked by magistrates Messrs Trevor Williams (presiding) and A. G. Lewis if she wished to speak on their behalf.

"We have no other place to go," she said. "We would be satisfied to pay a £1 a week to stay here but as it is now, we can scarcely get bread to eat, let alone anything else."

Lee said she was certain that the gypsies kept the common clean.

"We have to live somewhere my gentlemen, just the same as you." she told the magistrates.

Court Inspector J. Aitken said the object of the continual summonses was to "get rid of these people."

"Lydia Lee promised to leave the city in 1941." he said.

"You would not like to leave your own home." commented Queen Lydia.

Said Mr Trevor Williams: "Whilst I sympathise with you I must administer the law as it is. We must fine you for each day you live there."

When "Queen Lydia" asked for time to pay, Mr Williams said: "We are feeling charitable today. You will be given three months to pay all outstanding fines."

December 1955

WALES HAILS THE NEW CAPITAL

As soon as the news of capital status being granted to Cardiff was known in the City Hall, the Lord Mayor (Alderman Frank Chapman) authorised the calling today of a special meeting of the city council as a general purposes committee.

The Lord Mayor, who has been ill at his home in Pearl Place, Roath, Cardiff , for three weeks, issued the following statement:

"With reference to the Home Secretary's important announcement in the House of Commons. I invite the citizens of Cardiff , and as many as possible of my Welsh compatriots, to attend outside the City Hall on Wednesday, December 21, at 11.30am, when a public statement will be made.

"Flags in honour of the occasion are invited to be flown on all public and other buildings in the city – Cymru am Byth."

At midday the announcement will be made at the Exchange, Cardiff Docks. Docksmen and their staffs are asked to assemble at the Exchange.

Eighty-one-year-old Alderman Chapman was still in bed at his home yesterday when the deputy town clerk, Mr WG Hopkins, in the absence of the town clerk, Mr S Tapper-Jones (who was in London awaiting the Home Secretary's statement), called to give him the news.

The Mayor of Aberystwyth (Alderman WG Rowlands) said last night, "Aberystwyth has confidently based its claim for recognition as the capital of Wales on its central geographical situation and Welsh cultural background.

"Now that a declaration in favour of Cardiff has been made by Major Gwilym Lloyd George, Aberystwyth heartily and sincerely congratulates that city."

Mr JE Jones, organising secretary of Plaid Cymru, said the party welcomed the recognition and had always favoured Cardiff as capital . In as much as the usual meaning of a capital city was a seat of government, Plaid Cymru hoped Wales would move forward to make the title of Cardiff a reality.

Lord Ogmore said, "We have long waited for this moment, and I congratulate Major Gwilym Lloyd George and the Government on recognising the needs of Wales and the claims of Cardiff . I am very pleased that it was a Welshman who had the common sense and courage to take the decision.

"I am quite sure that our having at last a legally recognised capital will do much to encourage the realisation of nationhood among the people of Wales. I now look forward to Cardiff taking the lead in all national activities. The next step is the appointment of a Secretary of State for Wales, with his own department as in Scotland.

"I am glad to pay tribute to the Western Mail for many years of hard work, often in the most discouraging conditions, in this field. To them, more than to anyone else, is due the credit for the spadework leading up to the creation of Cardiff as capital of Wales.

"The Western Mail has also for years past, pressed for the appointment of a Secretary of State. I agree with them that this is a most desirable innovation and I hope that they will continue pressing for the appointment now that their efforts, and those of others with them, have been successful in securing capital status for Cardiff ."

Mr Goronwy Roberts, Socialist MP for Caernarvon, said that Cardiff deserved the loyal support of all the people of Wales. In return he hoped the new capital would see to it that it fully represented the spirit of the Principality.

"If Cardiff responds, it will take its place as one of the great cities of Europe, and not just one of the hundreds of English provincial towns," he declared.

Referring to Caernarvon, he said the elevation of Cardiff could make no difference to the rights and duties of Caernarvon, the ancient capital of Gwynedd, as the ceremonial capital of Wales.

Referring to the campaign for a Parliament for Wales, he said, "In due course, and sooner than many people realise, the Government of the United Kingdom will be organised on federal lines. In that event, Cardiff will have very special duties, and I should advise the city to prepare in every way for that happy occasion."

The Mayor of Caernarvon (Alderman William Hughes) said he would reserve his comment until "full information" was available.

The Mayor of Carmarthen (Alderman JJ Lewis) said Cardiff was the natural, cultural, geographical and business centre of the country.

Alderman BG Howells, chairman of Pembrokeshire County Council, said,

"It is a very well deserved honour for Cardiff and reflects the very high opinion held by the great majority of people for the progressive policy of Cardiff City Corporation in developing such a beautiful city centre."

Sir William A Jenkins, of Swansea, said, "I would like to see Swansea being designated a city. When the blitzed parish church of St Mary is rebuilt I think we can look forward to its becoming a cathedral and Swansea a city."

The Mayor of Llanelly (Councillor WJ Davies) said, "This is a great day for Wales."

The Town Clerk of Newport (Mr JG Iles) said, "We in Newport are very delighted." (The Mayor of Newport is indisposed.)

The Mayor of Merthyr (Councillor F Everson) said, "As Merthyr's Jubilee Mayor, I should like to extend my heartiest congratulations to Cardiff . It is gratifying to know that the Principality can now take its place with the other countries of the United Kingdom in having a recognised capital . I am sure that no better choice than Cardiff could have been made."

Alderman Sidney Cadogan, chairman of Glamorgan County Council, said, "The Glamorgan County Council is naturally delighted at the news. We feel that Cardiff is entitled to the recognition and, in fact, we have supported its claim to capital status from the beginning. Cardiff has always been our centre and the people of the Valleys have looked to Cardiff .

"We owe a debt of gratitude to the Government for deciding to recognise Cardiff 's claim."

Welsh leaders call on Lord Mayor

A courtesy call on the Lord Mayor of Cardiff will be made this morning by leaders of Welsh national organisations.

Members of the party will be: Lord Macdonald of Gwaensynor and Mr AB Oldfield-Davies (National Broadcasting Council for Wales); Sir Frederick Alban (Welsh Regional Hospital Board); the Rev William Evans (Royal National Eisteddfod of Wales Council); Mr HK Trimnell (Council for Wales); Mr P Leonard Gould and Mr AT Burton (Welsh Board of Industry); Mr SC Harris (Industrial Association of Wales and Monmouth); Major TH Vile (Welsh Rugby Union); Mr AMC Jenour (Wales and Monmouthshire Industrial Estates, Ltd); Major Creighton-Griffiths (Royal Welsh Agricultural Society); Dr Dilwyn John (National Museum of Wales); Mr WH Smith (Council of Social Services for Wales and Monmouthshire and the Welsh National Opera); Miss Janet Jones, Mr E Vivian Rogers and Mr HH Swift (Welsh Tourist and Holidays Board); and Mr T Mervyn Jones (Wales Gas Board).

MAKING CAPITAL

There was no official announcement in Parliament of the honour, but Cardiff West MP George Thomas dashed in the first reference to 'the capital 'MP George Thomas, remarking on redundancy, pointedly announced Cardiff 's capital status in the Commons, saying, 'There is great anxiety in the capital about this.'

Government had not considered it necessary that the announcement should be made by the Minister of Welsh Affairs on the floor of the House.

April 1956

DAVY CROCKETT VISITS WITH A MESSAGE FROM LA

Tongue-tied, but with stars in his eyes, a five-year-old Welsh boy gazed adoringly from his hospital bed at his hero come to life.

He could hardly believe it, Davy Crockett was there in Whitchurch Hospital, Cardiff – buckskin suit and all – sitting on his bed.

The "greatest indian fighter of them all" was actually talking and singing to him.

Was it true?

He reached out and touched the rough leather of Davy's clothes (seemed real enough) he touched the guitar his idol was strumming (it was a real guitar) he listened to the now famous frontier song.....yes it WAS true.

Davy Crockett was here. At least, people called him Fess Parker , but it was the same thing.

For Ian Smith, of Warns Terrace, Abertysswg, Rhymney, a dream had come true.

Ever since the legend was brought to life, young Ian has read about, talked about and heard about the man who was "born on a mountain top in Tennessee".

Afterwards, when the fuss had died down and Fess Parker , pictured above greeting fans at Cardiff General Station, was gone, a tearful Ian said: "It was wonderful, I've always wanted to see him and now I have. You wait till I tell Mammy about this!"

His father, Mr Roy Smith, said his son was not expected to live more than a couple of years. But for Ian, a dream had come true.

August 1956

SAUCY

'Saucy' gets a black-out

Two small slips of plain white paper helped save the honour of South Wales bill-posters.

Covering the words "saucy – this play begins where other left off," to large posters advertising next week's show at the New Theatre, Cardiff.

The firm which holds the contract for posting the bills refused to stick them.

"We have no objection to the play, but the posters were considered to be unsuitable for public display." explained a local representative.

"We have been advised by our national association not to take part in sticking them."

The objection was later cancelled when the bill-posters decided to stick two bits of paper over part of the poster.

The play's sponsor, Guy Charles, said: "It's the first time I have heard complaints about the poster. In Swansea, where the play Daughter of Desire was running all week, the manager said he had no complaints all week."

August 1956

SMOG IN SPLOTT

Smog means work for Splott

In Splott today housewives did the family wash for the second time in two days. And the Steelworks smog is to blame.

That's the name they've given to the yellow, acrid coke-oven gas that settled on Splott, Cardiff, about noon yesterday and persisted until evening.

It came from Guest Keen's steelworks, where hundreds of Splott men make their living.

Splott housewives are split into two factions over the smog. There are those who think "something ought to be done about it" – and those who are resigned to it, knowing that if there were no smog there would be no work for their menfolk.

In the former camp, a housewife in the worst affected area, who nursed a baby in her doorway as evil-smelling smog swirled around, said: "They say this stuff kills germs, but I think it will kill us first."

The views from the opposite camp were expressed forcibly by a housewife who lives a few streets away.

"What I say is, if there was none of this stuff there'd be no work, and then we'd have something to grumble about," she said.

"I remember the Depression all too well.

"We'd have been only too glad to see it then."

May 1958

AUCTION

No limbs – but there is an organ on offer

One-legged persons have been more careful in Cardiff during the past two years. Not one artificial limb has been found and handed in to Cardiff City Police.

And so this year, the Cardiff auctioneers will not have this familiar item on their list when they conduct the sale of unclaimed and confiscated goods which will be held by the city police at the Cardiff Law Courts.

But there will be one unusual lot at the sale – a grey-coloured organ, which swept into the news when it was found abandoned on the steps of the County Hall, early one morning. Extensive police enquiries followed but the owner never found.

There will be a large number of watches, bracelets and other jewellery. Even a new pair of baseball gloves and three giant-size lorry tyres will be there for the bidding.

May 1958

BRANDO

Baby for Brando's bride from Cardiff

Anna Kashfi, the Cardiff girl, wife of Marlon Brando, gave birth last night in Hollywood to a baby boy weighing 7lbs 10oz.

Twenty-three-year old Anna, whose real name is Joan O'Callaghan, married the film star in California on October 11 last year.

And at the time her parents Mr and Mrs William O'Callaghan, of Newfoundland Road, Cardiff, knew nothing about it.

Anna, who came to Cardiff with her parents from Darjeeling, India when she was 12, attended St Joseph's Convent School, just around the corner from her home.

She became an actress after working in a butchers, serving in a Porthcawl cafe and studying at Cardiff College of Art. She appeared in films with Spencer Tracy, Rock Hudson and Glenn Ford.

● This was Anna Kashfi as Joan O'Callaghan, 16-year-old Cardiff schoolgirl. Her long hair had not then been --'---'- back over her brow—but the basis of beauty was very much

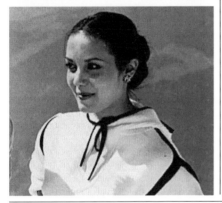

A South Wales Echo reporter went to quiet Newfoundland Road to break the news to Anna's mother.

Her brown eyes lit up as he read the news flash to her and she said: "I'm delighted. This makes me very happy.

"I knew she was having a baby but heard nothing about it from my daughter at all. We've had no letters from her since she was married.

"I'm hoping that they will come over now – all of them," she went on eagerly. "I'd love to see the baby – and of course my daughter and her husband."

August 1958

THE LONE RANGER

Thousands get a glimpse of Lone Ranger

THE Lone Ranger, Clayton Moore, the television cowboy who always wears a black mask, caused chaos in Cardiff.

Hours before he was due to arrive at the Cardiff store of Messrs. James Howell. Ltd., thousands of people, mainly children, thronged into the street to see him.

The heavy Thursday afternoon traffic in St Mary Street was practically paralysed as the children overflowed the pavements on to the roadway.

Parents had children on their shoulders and others who were pushed up on window ledges peered eagerly over the heads of the rest of the crowd.

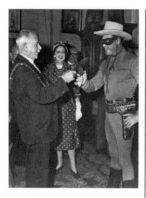
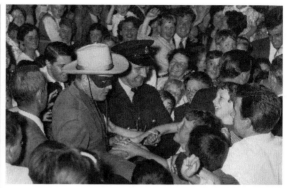

The Lone Ranger, who was due to arrive by car, was late – evidently held up on in the traffic.

When he arrived the crowd for a quarter of a mile radius was dense as for a Royal tour.

Meanwhile, hundreds of children were waiting in the queue outside the store hoping to gain admittance.

Inside the room where the Lone Ranger was to make his appearance, chil-dren and adults jostled and pushed to get nearer the platform.

Suddenly the cheers broke out from 500 throats... The Lone Ranger had arrived.

He gave them an old Indian greeting – "Faithful friends", twirled his six-shooter, and thanked all "You wonderful boys and girls," apologised for being late and fought his way through the door.

The event for which some had waited nearly three hours was over in five minutes.

Some of the waiting boys wore Lone Ranger suits.

One was seven-year-old Lyndon Hobbs, of Celtic Road, Gabalfa. Silent behind his sinister black mask, Lyndon stood deter-mined to get his man.

His mother, Mrs Florence Hobbs, said: "He has talked of nothing else for days."

July 1958

COMMONWEALTH GAMES
DUKE IMPRESSED BY THE GAMES

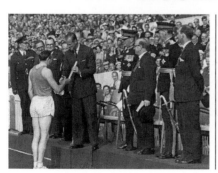
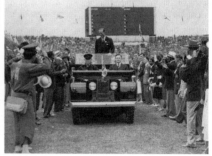

The opening of the Empire and Commonwealth Games was a "wonderful performance" said the Duke of Edinburgh today.

Speaking at a luncheon in Cardiff Castle, the Duke said he was delighted the Empire Games were being held in Cardiff.

"How impressed I was by the arrangements which had been made and the opening ceremony. It was a wonderful performance and I congratulate you."

It was later officially stated that the Queen would not be able to visit Wales and the Empire Games.

It was announced from Buckingham Palace that on the advice of her doctors the Queen has decided with much regret that she would not be able to undertake any public engagements before the end of the month.

The Duke of Edinburgh, pictured above at the opening ceremony, will carry out the programme arranged for the visit to Wales and the closing ceremony of the Games.

October 1958

SHOP 50 YEARS

Marie Lloyd – one of her customers

Marie Lloyd, the Bute family, Lord Tredegar – these are some of the customers Christina Jenkins has come to know during the past 50 years over her counter at Cross and Crouch Co Ltd, Duke Street Arcade, Cardiff.

Today, sadly, Miss Jenkins leaves the shop for the last time as an assistant.

Rather wistfully she recalled the day in October 1908 when she joined the firm.

"I worked from 9.30am up to nine or 10 at night and I was paid half-a-crown a week," she said.

Miss Jenkins has vivid memories of Cardiff in 1908.

"Duke Street has changed a lot since then," she said. "There were shops in front of the Castle where the green is now and of course the whole town was very much smaller."

October 1958

TRAIN JUMP

The wrong train – so he jumped

A Cardiff man going to Bristol to see his girlfriend found he was on the wrong train. It was going to Reading.

So he jumped out as the train was travelling through the Severn Tunnel railway station at 25mph.

He both hurt himself, and ruined his best suit.

At Chepstow today the man, Daniel Owen

Radford, of YMCA buildings, Station Terrace, Cardiff, was fined £3 for leaving a moving train.

"He is lucky to be alive to pay the fine." commented the chairman Mr Hubert Heath.

Railway-sergeant M J James said Radford told him that after the train left Newport he learned he was on the London train with the next stop Reading. The guard would not stop so he jumped off and fell on the platform injuring his face, shoulder and hands.

November 1958

CARDIFF BOY'S COURAGE WINS HEARTS

The courage and cheerfulness of a three-year-old boy have won the hearts of doctors and nurses in a Cardiff hospital.

The boy – Daniel Hobbs, of Clyde Street, Adamsdown, Cardiff – was rushed to Cardiff Royal Infirmary after his legs were trapped under the wheel of a heavy lorry.

His right leg had to be amputated.

The hospital had every hope of saving the other leg, which had been set in plaster.

The latest bulletin was that Danny had "improved".

"After the operation he asked for a glass of 'pop'," his grandmother Minnie McGrath told a South Wales Echo reporter, "He was always asking for 'pop' when he was at home."

A tricycle was Danny's most treasured possession. He was playing on it and was told: "Don't go away from the house."

"He never went further than the shop on the corner," his grandmother said "We always made sure of that."

But he ventured a little further afield and the accident occurred in nearby Constellation Street.

Afterwards, a man picked him up to make him comfortable. Danny said, "Put me down on the ground and let me walk."

In their trouble the family were also thinking of the lorry driver. "I would like to find out who the driver is to put his mind at rest," said Mrs McGrath.

"It was a terrible shock for him. He must have used all his strength to stop the lorry as suddenly as he did."

Danny was visited in hospital by his mother and grandmother, and has two younger brothers – Raymond, aged 13 months, and seven-week-old Colin.

November 1958

CARDIFF NEW BUS STATION

A mixed brigade of early morning travellers – office cleaners wearing colourful head scarves, uniformed railway workers, and businessmen carrying brief cases – informally opened Cardiff's new £22,000 central bus station today.

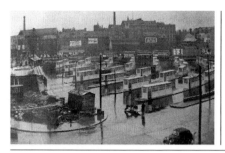

There was no sign of ceremony as they made there way to and from the buses – linking Cardiff with its suburbs and the towns of South Wales.

"Aren't we getting posh," joked the good-humoured cleaners.

"That's what I call door-to-door service," commented a railway porter. The businessmen just dashed for their trains.

January 1959

CLIFF MOVES IT

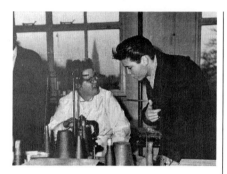

With a convulsive leap, the newest of the teenage idols was on the stage and snaking around the central microphone.

From all sides of the 2,500-strong audience rose an almost non-stop crescendo of screams – for the boys, who constituted a clear minority, they were quietly content to clap near off-beats.

Mr Richard is around 5ft 10in tall, is slimly built and has a smooth face which looks even younger than the 18 years he has lived.

Six months ago he was known as Harry Webb, an unknown junior clerk and the spare-time leader of a rock 'n' roll group which he called Cliff Richard and the Drifters.

Then he made a record called Move It and before you could shout "Oh Boy" the opus had moved him, most aptly into the television studios – and now the frantic world of one-night-stands.

His audience last night appeared to consist for the most part, not only of girls around school-leaving age but even less. Their screams rose, fell away sobbing, rose again – and again.

Since nothing Mr Richard, above, sings is even decipherable, and since every number sounds pretty much like every other number, it is clear that what the girls writhing in their seats for are the physical acrobatics, which so sharply remind you of Mr Elvis Presley.

What is Mr Richard like personally? Well he is pleasantly mannered and quietly spoken. Indeed, his voice is almost subdued as he explains that he doesn't understand legitimate music or grasp what jazz is about and only "feels" the beat when it appears in its over-simplified form in the rock.

He says he doesn't want people to say he is deliberately trying to look like Presley, though mention his name and Richard's eyes shine.

"Elvis" claimed Mr Richard earnestly, "is the greatest single artist of his day and generation."

May 1959

PLANE CRASH IN CARDIFF
Plane crash in Cardiff

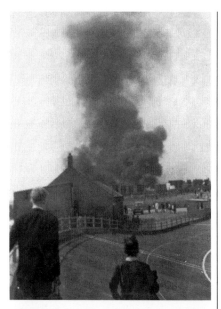

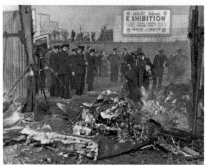

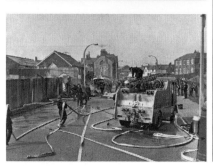

Four people were killed when a twin-engined Dove aircraft crashed on the main road at Maindy, Cardiff, this afternoon right outside the stadium where 400 children of Cathays High School for Boys were attending a sports meeting.

The aircraft exploded and part of it struck a van. Another part blew across Herbert Street to land alongside the railway lines leading to Queen Street Station.

The aircraft, a "flying showroom," belonging to Lec Refrigeration Company of Bognor Regis, visiting Cardiff for the Ideal Home Exhibition, took off from Pengam Moors "for a flip around the city."

Those known to be on board were: Mr Paul Chambers, pilot, a 24-year-old former Guards officer, of East Grinstead; Mr R L Burchell, the company's representative in Cardiff and Michael Dove, the co-pilot.

A passing lorry-driver who went to the aid of those in the plane suffered burns and was taken to Cardiff Royal Infirmary and then to Chepstow Hospital. He is Mr David Davies, aged 42, of Llwyncelyn Road, Swansea.

About half an hour after the crash firemen succeeded in quelling the fierce flames and recovered four bodies from the burnt-out craft.

Mr Charles Purley, of Bognor Regis, managing director of the Lec Refrigeration Company, examined the wreckage and then left with the police to try to establish the identity of the men killed in the crash.

People in the area thought the pilot was trying to make an emergency landing.

Mrs Dorothy Elias, of Maindy Road, said: "I had just got off the No. 38 bus,

and as I turned round I saw the plane crash into the road. The people started running towards it and I shouted 'Get back!' as the petrol tanks exploded. There was nothing anyone could do."

Thirteen-year-old Derek Edwards, of Tymawr Road, Rumney, who was at the school games on Blackweir said the aircraft passed over them three times.

"On the third occasion they signalled to us as they wanted us to clear away for them to come down. Some of us ran from the centre of the field, but the aircraft passed over.

"We saw her turn and as she did so her right propeller cut out, then as she vanished behind the trees the other propeller seemed to stop and we just heard a loud bang and smoke poured up into the sky."

Another eye-witness said the plane appeared to be trying to make an emergency landing and said there were two explosions when the plane was still in the air.

The plane "suddenly lurched" as it was crossing trees of Sophia Gardens and crashed near a garage on the North Road.

Mr George Foreman said: "The plane came skimming just over the chimney-tops, then it seemed to dive and hit the deck and a few minutes later it exploded. It was terrific. I was working only six or eight yards away from it."

Mrs Nancy Clarke, of Herbert Street said: "I ran down the street and petrol was flaming down the street into the sewer. I screamed and shouted, 'Petrol, petrol, lie down, lie down.' The 12 workmen in the yard of Miles Bros, building contractors, dived over the wall like rabbits."

Mrs Mary Jeans, who lives next door to Mrs Clarke, said when Mrs Clarke started shouting 'Petrol' I ran in the house and got my baby, who was sleeping, wrapped him up and ran down the street to safety."

Two policemen, Tony Howard, aged 22 and John Hughes, aged 23, ran to a nearby garage and dashed to the scene with fire extinguishers, but could not get near the wreckage.

Among the people who turned down invitations to go on the flight was the Chief Constable of Cardiff.

March 1960

STRIPTEASE

Cardiff 'Strip-tease in chapel' protests

Cardiff's first Soho-style strip-tease club may open in a disused Butetown chapel next Monday if protests from city councillors and church officials fail.

The Seven Arts Theatre Club's plans to use the old Bethel Baptist Church in Mount Stuart Square has been called "disgusting" and a "dreadful disgrace." But church officials have little power to stop the show going on.

"The lease we had on the church ended nearly 10 years ago and we moved to another building," said Rev William Davies, superintendent of Baptist Churches in South Wales.

In restructuring the inside of the chapel, a jukebox has replaced the organ and the vestry turned partly into a bar, the rest a dressing room for the girls at the chapel where composer Ivor Novello was christened.

Footnote: The Bethel Baptist Church later became well-known as the Casablanca Club.

April 1960

TIGER BAY
Visitors deterred by 'Tiger Bay' tag

Holidaymakers and organisers of conferences stayed away from Cardiff because they believed it was a city of "pitheads and Tiger Bay" it was suggested at a Cardiff parliamentary committee meeting today.

But Alderman C A Horwood commented: "People are beginning to look this way and become interested in the city as the capital of Wales.

"The name Tiger Bay does not now exist officially, but people all over the place refer to Tiger Bay and talk of it as a place of ill-repute."

April 1960

EMPTIES
1,500 empties in backyard

Called to a recently vacated house in the middle of the Canton area of Cardiff, men from Britton's Dairies Ltd, who supply many retail dairies in the Cardiff area, found over 1,500 empty milk bottles in a heap in the small backyard.

The bottles at a bottle a day comprise four years' supply. A dairy official said the bottles were all unwashed and could never be used again – a loss to the dairy of £37.

"This was just one of the many calls we receive to collect large quantities of bottles throughout the city, although we have never experienced anything quite like this before."

April 1960

CARDIFF PROMOTED
Cardiff City are there!

Hang out the flags and open the champagne bottles....Cardiff City are back in the First Division!

And by joyous coincidence, promotion came to them on the same day as their Golden Jubilee game at Ninian Park.

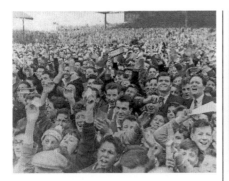

The suspense of the past few weeks ended dramatically this afternoon. Now the only question that remains is – will Cardiff City or Aston Villa be Second Division champions?

Whether or not City win that battle, their fans have plenty to celebrate tonight. And celebrate they will.

Let the Football Echo be the first newspaper to congratulate the board of directors, manager Bill Jones, right, and the playing staff.

Only two seasons have passed since Mr Jones became manager of the club. In that short time, with every encouragement from his directors, he has turned a struggling outfit into a promotion team, who next season will be entertaining such glamorous visitors as Wolves, Spurs, Arsenal and Manchester United.

This will be City's third spell in the First Division. May it become their permanent home!

August 1960 – LIGHTS ON

TONIGHT THE LIGHTS ARE ON AT CARDIFF CITY

Tonight's a big night for Cardiff City – and their fans – for at 8pm the new £26,000 floodlighting system at Ninian Park will be switched on.

More than 35,000 South Wales football fans will wait expectantly when City's first home game of the season, against Sheffield Wednesday, reaches the interval stage.

Then, in his instrument-packed cabin, handyman Bill Humphries will pull four huge switches to send light of 288,000 watts beaming down on the Ninian Park turf from four 150ft high towers now spanning the ground.

From that moment on Cardiff City will be "lit-up" in company with the majority of English league clubs – and the team's followers can look forward to a feast of illuminated football instead of being robbed by darkness of many midweek football treats.

November 1960 – LADY C

LIBRARIES BEGIN A NEW LADY C. ROW

News that copies of the controversial unexpurgated edition of 'Lady Chatterley's Lover' will be available in Cardiff and Aberdare libraries has met with a mixed reception.

A churchman, the Rev Griffith Jones told the Echo: "I think the literary merit of the novel does not compensate for the somewhat baleful influence it will have, particularly on young people.

"I do not think that 'Lady Chatterley's Lover' is going to have a constructive influence on the attitude of young people to sex."

A social worker, Mr Albert George, warden of a club for young people in Aberdare, said his 200 members did not seem unduly concerned whether they read the book or not.

"Personally, I am not very much struck, but I suppose it is a bit of a novelty for some people."

A headmaster said: "I have my personal views, but I would not impose them on others. I think whether or not pupils read the book is a decision parents should take."

Members of Cardiff libraries committee were told last night that two copies of a special 15s edition, available in December, would be bought first. Then, if there was sufficient demand a further four copies obtained.

December 1960

FLOODS
Danger is past for the moment

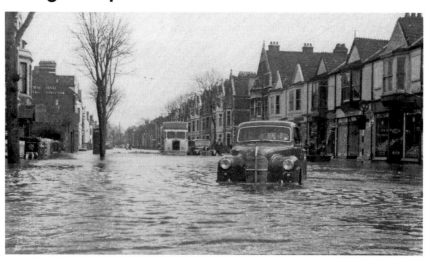

After 24 hours of anxiety caused by the worst flood to hit Cardiff in living memory, Mr E. C. Roberts, Cardiff's city surveyor, had this encouraging message for the weary victims today: "I don't think there is danger of further flooding at the moment."

This was the situation in some of the worst hit areas:

Firemen in Cardiff were still pumping water out of homes in the Cathedral Road area flooded to a depth of five feet yesterday. It is estimated that 6,000 homes in the city were affected by floods.

Cardiff telephone exchanges reported "no communications" from parts of the Rhondda, Pontypridd and Treforest. There was delay of up to two hours on calls from Cardiff, Merthyr, Swansea and Bridgend.

Officials at Treforest were trying to compute the damage at the trading estate. One estimate of the damage was as high as £6,000,000.

Gas supplies are still below normal and the Wales Gas Board has appealed to the public to "go steady in gas."

Two collieries, the Maritime and Nantgarw, out of a total of 14 in the Rhondda were out of action.

Measures to help protect Cardiff against future flooding have been recommended to Cardiff City Council by MR E.C. Roberts, the city surveyor.

Alderman H.E. Edmonds, chairman of the public works committee, told the council this afternoon that chief officials, who conferred earlier today suggested the following measures:

The embanking of the River Taff between Cardiff Bridge and Blackweir;

Improvement of the Whitchurch and Pantbach brooks, including enlarging the culverts under the railway and at the junction of Cathedral View and Gabalfa Avenue;

The embanking of the River Taff along the Taff Embankment.

But before the report from Alderman Edmonds came a question from Councillor Sidney Doxey. He asked:

"Following the weekend floods, will the Lord Mayor instruct the town clerk to prepare a report on the cost of this flooding and the method of dealing with this emergency for distribution to every member of the council?"

This was not meant to be a witch-hunt he told the council and added, "But having spent all Sunday working in the Riverside, Canton and Gabalfa areas. I am satisfied we have no effective, cohesive and practical plans for promptly dealing with disasters of this or a greater magnitude.

"Such a report as I request will make us aware of our short-comings and help us to learn from them and plan carefully to safeguard our citizens."

The Deputy Lord Mayor of Cardiff, Alderman C. Stuart Hallinan, said, "This tragic mass of water came like a thief suddenly in the night. We may not have prepared for it but we must live and learn."

He went on to say that he wanted to thank all people concerned in dealing with the tragic circumstances created by the floods, particularly "those marvellous women of the W.V.S."

The question of a fund to aid the flood victims was raised by Councillor David Purnell.

Referring to this the Deputy Lord Mayor said the disaster was so widespread he wondered whether they should consider a fund for Cardiff or for Wales as a whole.

He added: "If and when the relief scheme, in whatever form is established, the Western Mail and the South Wales Echo, with their usual ready to help and generosity, have agreed to assist in every possible way.

He said the Lord Mayor, Alderman Mrs Dorothy Lewis, who left for New York today, would give the matter her immediate attention as soon as she returned in four days.

The council passed a resolution expressing its gratitude to the many people who had helped in the flood. The council also accepted the report of Alderman Edmonds.

The managing director of a chain of Cardiff grocery stores has set a target of £3,000 for the fund for the worst-hit area of Cardiff-Gabalfa Estate. He plans to make the pay-out in the next two days.

Today Mr Idris Bateman was phoning the shops he owns in all parts of Cardiff and telling the managers: "Put boxes on your counters. Collect all you can."

Already he personally placed £100 in the box which lies on the counter of the Gabalfa Avenue shop he manages himself. It is the box which contained the money saved by his staff for their Christmas celebrations. Now the money lies with the £100 – as do many generous donations which customers and fellow shopkeepers have made.

December 1960

FLOODS
The Great Mop-up

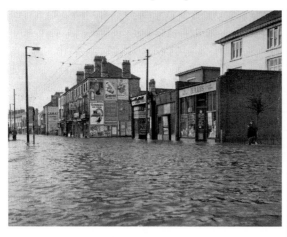

After 24 hours of anxiety caused by the worst flood to hit South Wales within living memory, Mr EC Roberts, Cardiff's city surveyor, had an encouraging message for the weary victims: "I don't think there is danger of further flooding at this moment."

This was the situation in some of the worst-hit areas.

Firemen in Cardiff were still pumping water out of homes in the Cathedral Road area, flooded to a depth of 5ft. It was estimated that 6,000 homes in the city were affected by floods.

Cardiff telephone exchange reported "no communications" from parts of the Rhondda, Pontypridd and Treforest. There was a delay of up to two hours on calls from Cardiff to Bridgend, Merthyr, Swansea and Porthcawl.

At Treforest officials were trying to compute the damage at the trading estate. One estimate of damage was as high as £6,000,000.

The Cardiff Arms Park pitch, above, was also affected with the famous turf flooded to a depth of three feet. The pitch was not going to be touched until an expert opinion had been sought by a turf specialist.

March 1961

CARY GRANT

Cary Grant charms film goers

Cary Grant escorted his wife Betsy Drake into Cardiff and captivated two audiences at separate functions and then bowed out to enjoy a late dinner – still radiating that million-dollar smile.

Success number one came at the Gaumont cinema in Queen Street. The "house full" notices were up when he stepped from behind the drapes to chat amiably with the audience there for 30 minutes.

The audience were put in receptive mood before he appeared by the screening of a trailer for his new film The Grass is Greener.

He joked about his teeth ("must have picked up the wrong set"), told a questioner that he loved his film love sequences, and informed another man that he couldn't think of anyone else he'd rather be – "I enjoy being Cary Grant," he said.

Afterwards he drove to an Angel Hotel reception to meet local celebrities, the Press and people in the film trade. Here he was joined by Miss Drake, who looked a little tired, but who joined bravely in the repartee.

A waitress approached with hors d'oeuvres on a tray. While her husband feasted his eyes on the delicacies, Miss Drake whispered from behind her hand, "It would be better just to leave the tray. You have no idea of this man's appetite!"

October 1961

WINDOW

Dropped in...with a bang!

Woolworths had an early morning caller at their Queen Street, Cardiff, store early today – straight through one of the 6ft-high plate glass display windows.

The caller, 18-year-old Wallace Coombs, of Mercia Road, Tremorfa, Cardiff, jumped off a trolley-bus, tripped over the kerb and went shoulder first through the glass.

He landed among the Christmas lights and other electrical gear, but was unscratched. "I just tripped and went

flying. I'm lucky that my shoulder hit the window first." he told a South Wales Echo reporter.

Completely unshaken by his experience, Wallace went on later to work at a nearby electrical store.

A spokesman for Woolworths said the incident happened just before the store opened.

"The first thing we knew about it was when a policewoman and Mr Coombes called to tell us."

February 1962

CLIFF RICHARD

Cliff upset at Cardiff show chaos

A second show stampeding at the Cliff Richard concert last night may have robbed Cardiff of another visit from Cliff.

"The audience was one of the worst we have ever come across." said Cliff's manager Mike Morris today.

During the demonstrations, a girl is reported to have a broken wrist, a policeman lost his wristwatch, handbags were damaged and buttons torn from coats as crowds fought their way through two entrance doors.

During the show, boys and girls were yelling. When Cliff came on there was a concerted rush from the back of the hall towards the stage which an army of stewards failed to control.

Said Mike Morris today as he and Cliff toured the Cardiff Blind Institute before

leaving for Taunton: "We don't want to play Sophia Gardens Pavilion again. It is not suitable for our type of show.

"It is an amazing thing, but there is nowhere in Cardiff now for a show like ours. The Gaumont was the only place. If we do have to come back here, I think we shall have to use the Capitol Cinema, and there, the stage is too narrow.

Mr William Phillips of Pontnewydd, telephoned the South Wales Echo to "register disgust" at the behaviour of the audience and the "inactivity" of the stewards at the show.

"People jumped on chairs, on other people's shoulders. The curtain should have come down to stop the mad behaviour."

Cliff's own opinion of the brawl, delivered as he chatted and joked at the Cardiff institute : "It was rough. I was sorry because I could not give a good performance under those circumstances. I love Cardiff, and up to now the fans have been fairly well behaved."

May 1963

BEATLES FIRST VISIT TO CARDIFF
Beatles and Orbison the stars

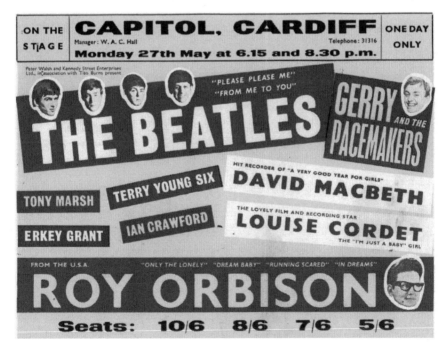

Capacity audiences packed the Capitol Theatre, Cardiff, last night to watch Roy Orbison, the Beatles and Gerry and the Pacemakers.

It was a remarkable show, not only because of the standard of entertainment, but because the teenagers had come to listen and appreciate.

The honours must be shared between Orbison and the Beatles, except for one distinction.

Whereas Orbison has created a combination of pop and American folk music, the Beatles have produced a new sound that comes nearer than any other pop trend to a folk music summing up the attitudes of the contemporary teenager.

Both, although different in style and presentation, were of the highest quality. They reached a height of entertainment that was the finest thing Cardiff will probably see for some time.

May 1963

WINKLE-PICKERS
Cut out the 'winklepickers' pupils told

A Cardiff headmaster has appealed to his pupils for the second time in public not to wear winkle-picker shoes, gaudy pullovers and narrow trousers in school.

"This form of dress is not permitted, especially when the school goes on trips to other towns," said Mr H C Eyre, headmaster of Fitzalan Technical High School, at the prize-giving at the Reardon Smith Lecture Theatre last night.

He warned the boys about the state of their clothes at last year's prize-giving they were still coming to school untidily dressed.

"However when a photograph was taken of the school then I must confess they looked the best dressed set of young men I have ever seen." added Mr Eyre.

While in school and on trips to other towns boys should wear blazers, school caps, grey flannel trousers and possibly grey shirts and pullovers as well.

Untidiness was also the theme of the guest speaker, Canon N G Matthews, Chancellor of Llandaff Cathedral, who warned the boys not to be sloppy in their use of language.

"English is one of the finest languages in the world and we must be constantly on our guard against commercial interests who seek to corrupt it and make ugly, said Canon Matthews.

...But This is what they wore today

...Today a South Wales Echo photographer went to the school and found some of the boys still prefer to follow the fashion trends rather than the head's advice.

In fact, a number of them did not appreciate the head's view at all.

"I don't see what he has against them," said one. "It doesn't make any difference really.

"I come to school wearing plain shoes and ordinary trousers – but as soon as I get home I change into winkle-pickers and tight trousers."

At a nearby school there was no ruling as to the dress. "We used to have trouble with the lads at school," said another boy.

"They use to tease us because we could not wear what we liked. Fights occurred over this but the teasing has died down now."

But headmaster Mr Eyre is adamant. "I've occasionally sent boys home for wearing extreme form of dress," he said.

Mr Eyre, aged 48, added: "I think I am right in trying to get the boys to have some standard of taste.

There is such a lot that lacks taste today and I think it is a school's duty to try and encourage boys to set themselves a reasonable standard in all things – not only dress."

He looked ruefully at a number of his pupils wearing winkle-picker shoes, and asked: "Aren't you uncomfortable in them?"

"No" one lad replied

"Well, I wouldn't know – I've never worn them myself. When they are worn out buy a sensible pair." he ordered.

June 1964

TAFF SWIM
Revival of popular 'Taff' Swim

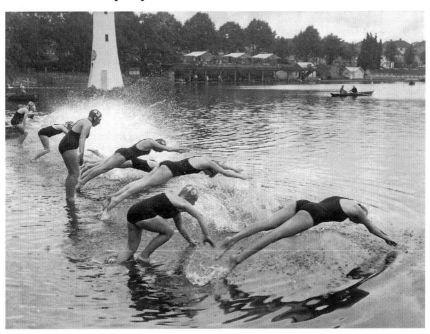

AFTER a lapse of eight years the most popular of swimming events, the men's and women's Welsh long-distance championship, better known as the "Taff Swim" will once again be open for competition.

This year, as in the few years prior to the war, it will be held in Roath Park Lake over a distance of 1¾ miles and will take place on Saturday, August 2.

There will be open and native championships for which four trophies, presented by the South Wales Echo, will go to the individual winners.

June 1964

WARM WELCOME FOR TONY

Mr Tony Ambatielos, above, who was freed in April after 17 years in Greek prisons as a political prisoner, was given a VIP welcome when he arrived at Cardiff General Station for a week-long stay in Wales.

It was laughter, tears, handshakes hugs and flowers all the way when Mr Ambatielos and his wife Betty, were greeted by more than 100 well-wishers.

Looking fit and sun-tanned Mr Ambatielos smiled broadly as he was welcomed by South Wales miners' leaders and other members of the reception committee on the station platform.

"I am very happy to be back in good old Cardiff where I spent many years during the war as a union leader.

"I will never forget the sympathy the people showed for my wife and I during our years of struggle.

"We have very close bonds with many Welsh families and I am very moved by this reception.

"It's just like being back in my home town."

Mrs Ambatielos, who has campaigned all over the world to win freedom for her husband, said: "Cardiff is like home. We met here when Tony was working at the docks and I was an evacuee from Birmingham."

June 1964

TOP RANK BAN

Top Rank aims to keep out troublemakers

TOP Rank Cardiff Suite has turned away between 60 and 70 casually-clad would-be dancers in the past three weeks in an attempt to "purge" the ballroom of a "certain element".

Today a complaint was lodged with the South Wales Echo by Miss C Bradford, of Llandudno Road, Cardiff. She said: "My boyfriend was refused admission because he was wearing a Beatle jacket and not a suit.

"Our evening was ruined."

Mr Ray Bain, general manager of the Top Rank Cardiff Suite, said: "That's very likely. There is a small percentage of people who although casually dressed are perfectly nice people. This is what appears to have happened here.

"We have nothing against Beatle jackets as such – but cardigans and jeans are out.

"We are trying to maintain a high standard and when lads turn up in casual wear we explain to them what we are trying to do.

"Ninety per cent of the lads appreciate it and some go home to change. When they do come back we make sure that they get in."

June 1964

HOSPITAL BEER

Beer flows as dental school is 'topped out'

IT WAS free beer for the workers today at the site of the first phase of the £13½ m University of Wales Teaching Hospital, Heath, Cardiff.

They have just reached the roof level on the £1½m dental school which is expected to be completed in October 1965.

A spokesman for the contractors E Turner and Sons Ltd said: "In a big contract when the roof stage is reached some firms celebrate this with a good drink for the workers.

"It is known as 'topping out' and this is the first time we have done this in South Wales."

About 200 men broke off from work at 11am prompt and climbed the 119 steps on to the roof of the dental school.

There they drank pints of beer from four barrels and shorts from another "bar".

Within 35 minutes the barrels were empty and stop-tap was mid day. Then the men – carpenters, bricklayers, plant operatives, electricians and labourers – went back to work.

June 1964

GAS BILL SHOCKER

Ted Brokenshire, a Cardiff bus conductor, had received a gas bill for £348. And his wife, Evelyn, who uses only a gas cooker and a gas poker, "nearly collapsed" when she read it.

"Usually our gas bill is about £3 or £4 a quarter. This amazed me and I asked the wife if she had been cooking for the army when I was out at work," said Mr Brokenshire, of Mannfield Street, Riverside.

Enclosed with the gas bill was a note informing consumers that it had been prepared by a new electronic computer – the only one used by any gas undertaking in Europe. It had been preparing bills for the past six weeks.

The cost of the computer? £150,000.

Mr Jones, chairman of Wales Gas Board, said that out of more than 35,000 computer-prepared bills sent out this was the second which was incorrect.

September 1964

BILL HALEY

Old man William taps nostalgia

Whisper it gently, William Haley is getting old. He came to Cardiff attempting to re-create the frantic atmosphere of his last visit six years ago, when he was king and creator of the rocking scene.

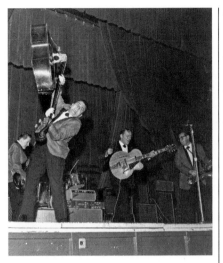

There was a shade less than a rave at Sophia Gardens Pavilion, Cardiff. He was clapped. He was cheered. But raised very few screams in his first concert of a nationwide tour with such young bloods as Manfred Mann and the Nashville Teens.

Despite the scene pictured below, there was no hint of the riotous ecstasy which shot him and the Comets to the top seven years ago with Rock Around The Clock.

The fans were saving their tonsils for younger things, things that came in the second half of the concert, the Teens and the Manfred men.

They got the bedlam, Mr Haley had to be content with nostalgia.

The show was far short of a sell-out and, surprisingly so, on paper one of the strongest attractions to go to Sophia Gardens in a long time.

At least two girls fainted, a modest pointer to a modest success.

March 1966

KINNOCK

Students are gagging me, says a president

Students Union president Neil Kinnock, below, claimed today fellow students at University College, Cardiff, were attempting to silence him in his attempts to explain why he resigned four days ago.

His resignation followed an argument over college representation at a national meeting to be held soon of the National Union of Students.

After his resignation he attacked the students' Representative Council alleging they were "less intelligent than usual this year with few exceptions". Six other members of the NUS committee also resigned in the row.

Mr Kinnock, a 24-year-old education student from Tredegar, said: "I have resigned on a matter of principle because the students' council has once again interfered unnecessarily in a committee's affairs."

Kinnock, who was elected by a record majority last year, said: "I have tried to get permission from the council to explain to the student body at a general meeting why I have resigned. But so far they have refused permission."

November 1967

BOMB WRECKS THE TEMPLE OF PEACE

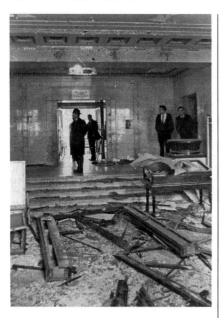

THE entrance hall at the Temple of Peace, Cardiff, was wrecked by a saboteur's bomb early today – only hours before the opening of an all-Wales conference at which 450 civic leaders, Lord Snowdon and the Secretary of State for Wales, Mr Cledwyn Hughes, were to plan celebrations for the investiture of the Prince of Wales.

Massive chunks of masonry were ripped from the face of the building and hurled 30ft away by the blast, which was heard throughout the city.

Police immediately sealed off the city, and main road traffic leaving Cardiff was searched.

The conference, due to open at 11.30am today and to be attended by local authority representatives and leaders of national organisations, will take place. Police said the conference room was usable, although the organisers said that, if necessary, the meeting would be switched to another building.

Police started a massive search of the city immediately the blast rocked the capital at 4am. Patrol car officers found that the explosion had occurred behind the heavy metal doors of the Temple of Peace in King Edward VII Avenue.

Debris covered the floor of the entrance hall to the building. And the glass doors beyond, leading into the conference room, were smashed and twisted by the blast. Inside the entrance hall, I found bricks and tiles were ripped from the walls. Plaster and woodwork hung from the ceiling, display cabinets were shattered and light fittings smashed.

Heavy ornamental ironwork had been torn from the metal doors, and glass from broken windows carpeted the steps and pavement outside.

Windows in the Welsh Board of Health building across the road were also damaged, said one police officer.

April 1968

NEW CURRENCY BAFFLES SHOPKEEPERS

BRITAIN'S first decimal coins were treated as foreign money in Cardiff yesterday. Sharp-eyed shop assistants, bus conductors and licensees took one look at the shiny 10 and five new penny pieces and refused to accept them.

Only one shopkeeper recognised the coins, which are to be issued on Tuesday, and he was prepared to accept them. Nobody else knew they were coming into circulation soon.

It will take time before the new coins start appearing regularly in change, as the number to be issued is very small compared to the existing two-shilling and shilling pieces.

The Decimal Currency Board says they are exactly the same weight and metal content as the present coins. But almost everybody who rejected them yesterday claimed they spotted the coins because they were lighter than usual.

Mrs Connie Bullen, of Cathays, Cardiff, who was given a 5p piece in a tobacconist in St Mary Street, said: "I took it as a shilling but it was a bit light. I thought it was a foreign coin, and then I saw the Queen's head."

An assistant on a stall in the market, Mrs Rita Dakin, of Ely, also thought the new coins were an attempt to pass foreign money.

"I have not seen them before. I could feel there was something different about the coins," she said.

But Mr J H Davies, a newsagent in Cowbridge Road East, spotted the new coins immediately.

The 5p piece proved unacceptable on a 10B trolley bus in Cardiff. The conductor, Mr U K Malawala, rejected it as a foreign coin.

"I have never seen them before," he said.

The coins were also rejected in the Queen's Vaults, Westgate Street.

May 1969

ANTHONY HOPKINS

Hopkins comes home

Anthony Hopkins, taking a few days off to "come home" from a more demanding stage and film career, talked to students at the Cardiff College of Music and Drama, where he had his early training.

Born at Port Talbot, Anthony's parents now live at the Ship Inn, Caerleon, where he is staying.

Mr Hopkins told of his acting with and learning from such people as Sir Laurence Olivier and Katharine Hepburn.

Of Sir Lawrence Olivier he said: "I have stood in for him occasionally – once in the leading role of Strindberg's The Dance Of Death. You have to reckon with 45 years as an actor and Olivier has the skill to take you apart in little pieces, rebuild you and leave your personality in the part intact."

Mistakes, he said, are blessings because in correcting them one learns. Perhaps one drawback in playing with Olivier was that he wanted to act every part and was able to

do it. Film making is very profitable, but one should return to the stage at intervals to "replenish the reservoir. Ideally, one should be a student all the time".

Katharine Hepburn, pictured in a scene from The Lion In Winter, he said, was probably the greatest film actress he had worked with.

Unlike so many others, she was entirely unselfish and willing to give advice to anyone who wanted to listen.

May 1968

BOMB WELSH OFFICE
Saboteurs attack Welsh Office

SABOTEURS blasted the main administrative block of the Welsh Office in Cardiff today in the third bomb outrage in the city in the last seven months.

Offices were wrecked, doors and windows smashed, when the bomb went off on a basement window ledge of the building – which also houses the Welsh Board of Health – shortly after 3.30am.

The explosion happened only a few yards from the Temple of Peace, the entrance of which had been wrecked by another bomb in November last year.

A patrolling policeman was only 50 yards away when the bomb went off this morning. Squads of policemen from the nearby police headquarters were on the scene in minutes.

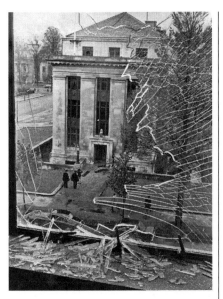

Roadblocks were thrown around all the exits of the city and all motorists were questioned.

Offices in the basement of the building were severely damaged by the blast with furniture, papers and broken glass scattered all over the rooms.

Every pane from the tall decorative windows along the Museum Avenue side of the building was blown out.

At the City's police headquarters, less than a quarter-of-a-mile away, high- ranking officers, including Mr John Parkman, head of the South Wales regional crime squad, held an emergency conference to organise the police hunt for saboteurs.

Detective Chief Superintendent David Morris, head of Cardiff CID, said early today, "No detailed estimate has yet been made as the extent of the damage.

"There was no-one in the building at the time and no-one was hurt."

Superintendent Morris said that they were anxious to trace the drivers of three cars.

July 1968

HEARST

Women 'horrified' when bodies fall from hearse

Women and children were horrified when two bodies fell from a hearse at a busy Cardiff road junction yesterday.

Today representatives of the National Association of Funeral Directors were trying to trace the undertaker conveying the bodies to the funeral home from a hospital.

The incident took place at the junction of Leckwith Road and Atlas Road, Canton. Shoppers and several children were among those who saw what happened.

The driver of the hearse and workmen quickly put the bodies back into the vehicle.

Mrs Katherine Davies, of Canton, who was standing nearby, said: "The driver pulled up rather sharply and the two bodies fell into the road. Some men working on telephone lines helped put them back and the hearse drove off."

April 1970

CARDIFF'S TALLEST BUILDING IS OPENED

Cardiff's tallest building, the 270ft Pearl Assurance Building, was officially opened today by the Lord-Lieutenant of Glamorgan, Sir Cennydd Traherne.

Sir Cennyd unveiled a plaque to commemorate the event and said: "A city is a place of buildings in which commerce and trade flourish. Without commerce there would be no buildings and no city."

He said the new building manifested the confidence held in Wales and its capital city.

Sir Geoffrey Kitchen, chairman of the Pearl Assurance Company, presented Sir Cennyd with a silver salver engraved with a picture of Pearl House.

He said: "I find that this is the most attractive building," and he congratulated those responsible for building it.

August 1970

IT'S NOT JUST A KNOCKOUT – IT'S A SELL-OUT

The walls of Cardiff Castle echoed to the roars of the crowd and the hooters of the German supporters last night as the British heat of Jeux Sans Frontieres (It's a Knockout) ended in a draw between Belgium and Switzerland.

The two teams scored 40 points each with Britain third with 37.

The contest was a sell-out and the audience was delighted. Said Coun Julius Hermer, chairman of the Cardiff organising committee: "It's been a great success, and we are very pleased."

Had it not been for an unlucky chance in the Rope Swinging Chute Game, in which Britain played her joker, Lowestoft, representing Britain, might have been the victors. They also suffered set-backs in the final game, Maiden In Distress, where they started well ahead but finished last.

A team is allowed to play its joker in one of the games and entitles them to double their points at the end of it.

The result means that Lowestoft have the highest placing so far of British teams and stands a good chance of getting into the final, said their team captain Mr Jeff Frost. "We are very happy about the result and have every confidence that we shall get to the finals." In the final, the best team from each country goes forward to the final play-off.

In the rough and tumble of the contest, which involved rope climbs, balancing on heights and leaps into mid-air, two of the French team were injured. They were taken to Cardiff Royal Infirmary with torn muscles but were not detained.

Their accidents brought the total number of injuries throughout the dress rehearsal and actual contest to 11.

The games for the heats are decided by a European committee and experts can tell which country suggested each game.

Apparently the British choose the games, while the Germans love games involving dressing up. The French, on the other hand, want dangerous games, and many of their suggestions have to be turned down because they are too risky.

September 1970

HAIRCUT OR STAY OUT, HEAD TELLS SIXTH-FORM REBELS

Fourteen Whitchurch High School, Cardiff, sixth form boys were sent home by their headmaster today because their hair was "unresonably long."

A week ago the headmaster, Mr A J C Morgan set a haircut deadline for about 35 of his pupils.

"All the boys were warned last school year that we would take more stringent measures this year if hair was not cut to a reasonable length as stated in the school rules."

Last Wednesday he repeated the request to the sixth form.

"I thought I was being fair in giving them a full week to have their hair cut. Today was the deadline. Fourteen boys did not satisfy the rule so were sent home.

"I have sent letters to their parents saying the boys' hair is excessively long.

I told the boys not to return until their hair is cut. The implication is that they can't come back until they do."

Mr Morgan emphasised that he has no desire to jeopardise the boys' future school careers.

"If their parents want to come to school I'm quite willing to talk it over," he said.

The headmaster already has the backing of the school's parents' association.

Mr Morgan attended a committee meeting of the association on Monday and received their support in his action.

Several of the Whitchurch boys joined a demonstration outside the office of Cardiff's director of education Mr A J Mackay, after school yesterday. More than 60 pupils, mainly girls picketed the office carrying banners demanding the removal of "petty restrictions" in schools.

February 1971

TREMORFA ROLLS OUT 5,000,000TH TON

The wire rod mill of GKN (South Wales), at Tremorfa, Cardiff, has rolled the 5,000,000th ton of rod produced since the mill was laid down in 1950. it was disclosed today.

Since the first ton of rod was rolled there in the summer of 1950, it has taken 16,782 shifts to reach the five million mark. During the life of the mill, crew had reached an average shift output of 298 tons.

Originally, the Tremorfa mill was designed to produce 4,300 tons a week, but modifications in 1959 and 1961 increased the average capacity with culminating in a record 9,000 tons year.

March 1971

CITY SHOCK MIGHTY REAL

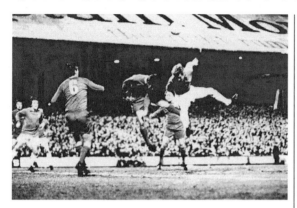

MAGNIFICO! That's Cardiff City after their taming of the soccer senors of Real Madrid.

Striker Brian Clark was the hero of the hour in last night's glittering European Cup-Winners Cup quarter-final first leg win at Ninian Park, Cardiff.

Burly Clark rose to the occasion and crashed home a vital goal in the 32nd minute with a glorious header. It was a night to remember – and a tremendous tonic for Welsh football in general.

Cardiff ran themselves to a standstill and, make no mistake about it, this was a brilliant team performance.

There will be talk about whether a one-goal lead is sufficient but, remember, City have gone abroad in the past with such a narrow lead and have succeeded.

City were two or three goals better than their celebrated opponents on this occasion and believe that Jimmy Scoular's men must be confident of a repeat in Madrid on March 24th.

Real will certainly have to come out more than they did in this leg – the Cardiff team have that semi-final look about them.

City's non-stop power work bothered a normally well-drilled and cool defence, with even Real skipper Zoco shaky at times when under severe pressure.

Although without striker Alan Warboys, City proved they are capable of breaking through a team with one of the best defensive records. Real have conceded only one goal in their last six Spanish league matches.

It was fitting that Nigel Rees, the centre of such a club-or- country controversy in recent weeks, should make the Clark goal. Goalkeeper Eadie was rarely troubled and, when he was brought into the game, handled cleanly and well.

October 1971

STRONG PONG

The riddle of the strong pong over Cardiff

Phew. That smell that reeked in Cardiff today really had people sniffing the air with worry.

Some said it smelled like an army of cats. Others suspected gas, and office workers and housewives started worrying about leaks.

The pong was particularly strong around British Railways head office at Marland House, the bus station, St David's House and Thomson House and city centre.

What caused it? It was the smell of gas... but only the smell.

An apologetic spokesman for the Wales Gas Board said: "It was no gas leak and not dangerous but the odour vapour that gives gas its distinctive smell.

"Some was accidentally released into the air from the Grangetown works.

"It was being transferred from one tank to another and as soon as it was released, carried over the city centre. We apologise for the inconvenience."

May 1972

BEDSIDE MANNER

Watch your bedside manner when visiting

Hospital visitors should avoid talking to patients about their own operation and should always sit on one side of the bed so that the patient doesn't feel like a spectator at Wimbledon.

These are just a couple of the hints in a booklet issued by the University Hospital of Wales to help visitors.

It goes on to advise them to keep the patients cheerful and avoid talking of the "latest disasters" or anything depressing.

"It is useful to remember, too, that your patient may have been saving up things he or she wants to say to you – so give them chance to talk as well," says the booklet.

Smoking is taboo while visiting and the "patter of little feet" can be unnerving to sick people. On the other hand, a visit by a child can be an absolute tonic. Either way, a chat with the ward sister is advised.

It is suggested that just one person rings the hospital for progress checks and passes on the news – thus avoiding jams on the switchboard, which also have to deal with emergencies.

The booklet is one of five issued by the hospital and aims to help people in a language they would understand.

June 1972

MONEY BACK CRICKET FANS

'Money-back' offer to the fans

A money-back offer to Glamorgan cricket fans was made by county secretary Wilfred Wooller as a protest against the tactics of Somerset skipper Brian Close.

 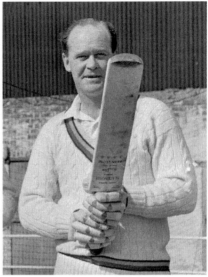

In an announcement over the public address system, Mr Wooller said: "If any supporter on the far side of the ground is prepared to ask for his money back, I am quite prepared to consider the application."

He made the remarks at the end of the luncheon interval after Close, the former England and Yorkshire captain, had decided to continue the Somerset innings.

Somerset had upset Glamorgan supporters with their snail-like progress after a delayed start which had taken more than two hours' play out of the match.

Mr Wooller said later his only worry was for the spectators. They provided the money to pay the players to provide the entertainment.

Close dismissed Wooller's announcement as "bloody ridiculous".

October 1972

RATS

Graduating to rat-catching

Cardiff is attracting a new breed of rodent operatives to deal with the city's rats.

Members of the city management services committee, which makes staff appointments for the council, were astonished to hear that university graduates had applied for a job as assistant rodent operative.

Dr J M Hughes, deputy medical officer of health, said: "When we advertised this

post we heard from candidates of a far higher calibre than we expected, including university graduates."

The committee thought they could smell a rat and one member wanted to know whether a man needed an arts of science degree to be a rodent operative.

A spokesman for the public health department explained they were looking for

"a smart, active man able to deal with the public and help supervise other operatives".

"He would have to learn how to mix poisons and should be able to keep up with the technical literature issued by the Ministry of Health.

"I suppose this reflects the current unemployment problem," he said.

January 1973

GOLDILOCKS

Baby bear has supper – after all

A little girl's birthday wish came true last night when she meet the "baby bear" appearing in Cardiff's pantomime, Goldilocks.

Three-year-old Shirley Wilson was upset when she saw that "someone had eaten baby bear's porridge" and ever since had been trying to ring up the bears on her toy telephone.

Her mother, Mrs Ray Wilson, Rhiwbina, Cardiff, said Shirley was anxious to share her birthday cake with baby bear to make up for the porridge.

She contacted the producer, Mr Tony Cundell, who arranged the meeting, where Shirley held the bears hand and was able to share her cake.

May 1973

WINGS

Former Beatle Paul McCartney made a triumphant return to Cardiff after an absence of more than six years.

Along with his group Wings, Paul took Cardiff's Capitol Theatre by storm and proved to all the 2,500 audience what a fine musician he still is with a sparkling personal performance, particularly on vocals and bass guitar.

The highlights of the programme, which lasted about an hour, was a song banned by the BBC – Hi, Hi, Hi – and the title number of the new James Bond film Live And Let Die, which the band wrote.

Backing Paul was the enthusiastic drumming of Denny Sewell and the controlled guitar work of Henry McCullough and Denny Laine.

In tribute to the Moody Blues, a band Laine used to play for, Wings gave a competent version of the Moodies' hit of a few years back, Go Now.

Fans laid siege to the stage when the band broke into The Mess, a pure,

unadulterated Rock and Roll number. C Moon and My Love were well received, along with a collection of songs from their new album release Red Rose Speedway.

Also featured in the show were the group Brinsley Schwartz who got sympa- thetic applause from an audience obviously glad to see the back of them.

In the interval there was a novelty act which included a poodle jumping through big hoops and a woman dressed up as a gorilla prancing around.

May 1974

'SHUT-UP' ABOUT THE EXORCIST – ADVICE

Councillors who want to stop the showing of the controversial film The Exorcist in Cardiff were today given a bit of advice by another councillor who has already seen it - "Shut up and keep quiet."

This was the advice which came from Newport councillor Paul Flynn who was one of the town's committee which gave the go-ahead for it showing there after they had seen it.

He said today, "the best thing that councillors who want to stop the film being shown is to shut and keep quiet – all banning it in Cardiff will do is ensure that it will run to packed houses in Newport for extra weeks."

Coun. Flynn said he thought the film "nauseating and cheap," but added: "It is stupid to view it in private session. We saw it in public and were able to judge the reaction of the audience. Scenes that were supposed to make one recoil in horror were greeted with hoots of laughter and if there was a steady procession of people leaving the cinema it was only to fill up on ice cream and lemonade.

"If Cardiff city's fathers want to stop people seeing this film then just let it go ahead. If they ban it people will want to see it all the more.

"The whole film is made to cash in on publicity that any ban will give it. But we

in Newport decided that the film seen in context of a full audience of adults, was no more frightening than Dr Who.

"It is the publicity that so-called well-meaning councillors create when they try to ban it that made it a box-office hit."

Coun. Flynn is a member of Newport's Public Works Committee that gave the film the go-ahead, after the film had already started its run in the town.

Said Cardiff councillor Stefan Terlezki today: "I think the advice to shut up is very valid – but it is not the answer. I wonder if Newport would have let the film go on if they had not been too late?

"Keeping quiet is sound advice, but it is also ignoring the problem and we cannot just sit by and do nothing.

"We shall view the film as a council in the morning and I cannot see any way in which we can get the public along for the showing and then, if the film is banned, exclude their fellow citizens from seeing it.

"We are elected representatives of the people of Cardiff and pledged to look after their interest and that is what we shall do, but I am going in with an open mind. I shall make no decision until I see the film."

May 1974

THE EXORCIST WILL BE SHOWN IN CARDIFF

The Exorcist WILL be shown in Cardiff. The decision was taken yesterday by the city's licensing sub-committee, which voted three to one in favour of the public being allowed to see the controversial film.

The four members of the sub-committee were told at a full meeting of the council that they had the power to say yes or no to the film being shown in the city.

The four then listened for more than an hour to the comments of other councillors, who were allowed into their meeting.

Coun. Stefan Terlezki, who had opposed the screening of the film in Cardiff said the decision should have been made by the full council.

"We represent thousands of people and we should have a chance to say yes or no on this issue. You are bulldozing this decision through."

He went on. "I think it is disgusting when three members of the council can decide for the people of Cardiff what filth they can see.

"The 15-year-old girl, who plays the lead in the film has been affected by the role she played as the young girl possessed by the devil.

"Her mother said the adverse publicity her daughter had received over the film had ruined her daughter's life."

A councillor who was in favour of screening the film, Mrs Maurita Matthewson described it as "unpleasant."

"it insults your intelligence, being full of scenes where gallons of tomato ketchup and green paint are used as blood and vomit. However, if you ban this film you must ban all the books from which the film was adapted. Any bookshop in Cardiff sells The Exorcist and any child can buy it."

Coun David Evans said the entertainment value of the film was nil, but if the public wanted to see it they should have the choice.

"What remains to be said is that in the film the Almighty triumphs over Old Nick in the end, so it is good in that respect."

Coun Nicholas Jenkins said some films shown in Cardiff are more dangerous than The Exorcist.

"The Kung Fu films teach people how to kill. I would consider The Exorcist less dangerous to young people. We must make sure, however, no-one under the age of 18 is allowed into the cinema."

Coun Bill Carling said the people who made the film are"sick in the mind."

"But I would not ban it. The book is in my house if anyone wants to borrow it, but, honestly, I was more scared watching Frankenstein 40 years ago."

Coun Fred Tyrrell described the film as "a load of rubbish.

"However, if people want to waste their cash paying to see rubbish, I don't want to stop them."

Mr Peter Edmunds, the deputy manager of the Olympia cinema, were the film will be shown on Sunday, said today: "I am delighted the committee passed the film for adult viewing. We can now look forward to crowds rolling in."

June 1974

THE EXORCIST: SOME WALK, SOME FAINT...AND SOME JUST LAUGH!

A MAN was violently sick and young girls fainted. Some people left the cinema shaking and some consulted a clergyman and a squad of helpers outside the cinema.

These were just some of the scenes witnessed at last night's showing of The Exorcist.

Four St John Ambulance officers stood by to give first-aid help.

But gruesome scenes and swearing in the film made a large proportion of the audience burst out laughing.

All but a few seats in the 1,800-capacity house were filled last night for the award-winning film in its first week in the city.

One man, aged about 30, rushed out during the showing. He vomited in the foyer. Other people were also sick.

Three young girls fainted and were given help by the St John men.

A St John superintendent said: "One man made it out of the cinema before being ill. This often happens.

"Some people have been leaving looking queasy. A lot of people are shocked at one scene which merely shows a real-life operation."

A young housewife who needed "reassurance" from a minister after the film, 19-year-old Mrs Geraldine Gape, Pentrebane, Cardiff, said she would not watch the film again "even for £1,000".

She said: "I was disgusted. It was revolting and blasphemous. I needed to speak to a clergyman after seeing it. It was horrible."

An 18-year-old hairdresser, Karen Bridger, said she was shaking after seeing the film. She had only gone out of curiosity.

Some left the cinema during the film.

Clergymen in Cardiff have complained about the film, stating it torments people. The religious squad outside the picture-house at every showing were handing out leaflets attacking the film and giving numbers people can ring if they are disturbed by what they have seen.

September 1975

POWERBOAT RACES LIFT OFF

The world powerboat championships roared into life at Cardiff's Bute East Dock this week.

After a short delay as the race rules and regulations were explained to 100 drivers from all parts of the world the event got under way with a spectacular display of racing over a course specifically laid out in the dock.

The championships, sponsored my GKN Rolled and Bright Steel Ltd, were organised to coincide with the near completion of their new £20m rod mill being constructed alongside the dock.

Despite preparations for a crowd nearing the 40,000 mark, vast areas of the dockside where special grandstands had been constructed remained empty at the start of the event.

April 1976

STEEPLE-JACK

And now there's a Steeple-Jill

Of all the dangerous male jobs none seemed safer from female intrusion than steeple jacking.

That is until 18-year-old Anne Cachia, decided to join the tough, daring breed.

For a year she's been scaling massive chimneys which would turn most men into cowards at the thought.

Anne is a partner, along with her fiancé and two others in the Cardiff steeplejack firm of Parish and Parish.

"It was by accident I started. One day I had to go out on site and ended by going up." She hasn't looked back ...or down, since.

May 1975

TERRIFYING ROLLERS

Terrifying! Ambulance man's verdict on city Rollermania

Ambulance chiefs called for tougher safety measures at pop concerts after scores of youngsters were crushed at Cardiff concert by the Bay City Rollers.

Wave after wave of hysterical fans stormed the stage at the Capitol Theatre in Queen Street.

They crushed and trampled on dozens on dozens of fans.

At least 20 fans were ferried by a fleet of ambulances to Cardiff Royal Infirmary for treatment.

Another 60 were treated at the cinema by St John Ambulance while four adults and a woman police officer were also injured.

Most of the fans hurt were young girls.

Ambulance superintendent Jim Clark described the night as "a terrifying experience – the most frightening I have ever known."

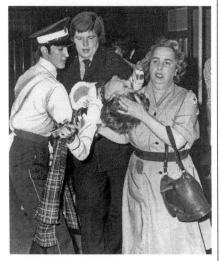

"In all my 23 years of service I have never known a night like it. I will never know how somebody wasn't killed in that cinema last night.

"Something has got to be done in future to protect people who attend these concerts. I would ask the authorities in charge to look at the situation carefully before doing this again.

"If they're going to stage this sort of show again the front six rows of seats should be taken out and crush barriers erected to give the police and security men a chance.

"There was a definite danger to life and limb in that cinema last night."

Sean Hackett, of St John Ambulance, criticised the switching off of all the theatre lights several times during the Rollers' performance.

"It may have been a gimmick for effect but it caused us an awful headache. We were blind and unable to cope each time it happened," he added.

A spokesman for Rank Leisure Services said today they had no intention of barring the Bay City Rollers from their theatres.

May 1976

FENCES FOLLOWING CROWD TROUBLE

Now City may fence more fans in

NEW measures to combat crowd trouble are expected to be considered by Cardiff City Football Club as a result of the ugly scenes at Saturday's Wales v Yugoslavia European Championship game at Ninian Park.

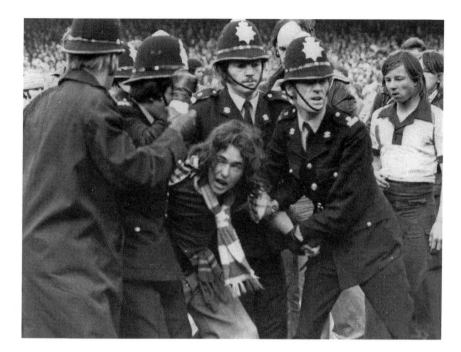

Both City and Wales face bans from European competition following the fury that erupted on Saturday.

Wales could be banned from all European competitions – and Ninian Park could be blacklisted for European matches.

UEFA, armed with reports from East German referee Rudi Gloeckner and their assessor, Mr Necdet Cobanli, of Turkey, will discuss the incidents at a disciplinary committee meeting in Switzerland.

Mr Lance Hayward, secretary of Cardiff City FC, said: "In light of spectators getting on to the pitch from the enclosure and Canton Stand our board will probably consider the need to fence off the pitch from these parts of the ground as well.

"As for existing fencing not being high enough because it was scaled by several fans, how do you decide what height it should be?

"No-one has ever climbed over it before."

January 1977

'DOG HOUSE' ROW

20 dogs' in her house, and neighbours want them evicted

Twenty dogs live in the home of Miss Margaret Williams, according to her neighbours. And they want the dogs out.

They say the animals cause noise and smell and are a public health hazard.

And now Cardiff City Council are ready once again to evict the dogs from Miss William's home in Richards Street, Cathays.

The council have evicted the dogs before and now Miss Williams is defying a court order to get rid of the animals.

Miss Williams, right, insists that she will not part with her pets. She

described the house as "derelict, but not dirty."

"I love dogs, they are my life and if the council take them away, I will fill my house with Alsatian guard dogs to stop them trying in future." said Miss Williams.

Next door neighbours Mr Clive James and his wife Christina, both say they have been complaining for years about the situation but nothing seems to be done about it.

"They take one lot of animals away and in a short while she fills the house up again and the whole legal process has to be gone through once more. These dogs create a terrible smell and during the hot summer last year it was almost unbearable," said Mr James.

June 1977

SILVER JUBILEE BEACONS
Silver Jubilee beacons beat sabotage

FOURTEEN huge beacons were lit throughout Wales last night as the Silver Jubilee celebrations went into full swing.

One of the blazing landmarks was near Corwen, in Clwyd, where a republican attempt to sabotage the festivities was thwarted by volunteers who rebuilt the beacon after it had been fired 23 hours earlier.

The first of more than 100 major beacons in Britain was lit by the Queen at Windsor. The others rapidly followed until a UK network was blazing.

The Welsh chain was sparked off with the lighting of a 30ft-high bonfire in the grounds of Cardiff Castle.

The weather forecasters said last night that Jubilee Day will be chilly and showery, but with some sunny intervals.

With the prospect of showers jeopardising street parties, some organisers

have been searching for indoor sites to ensure their festivities go ahead whatever the weather. Hundreds of other organisers, with no viable alternatives, will be keeping their fingers crossed and hoping that the big day does not turn into a big wash-out.

The forecast was for a sunny morning with showers moving in later, and fresh to strong winds. So the best advice seems to be: wrap up warm.

In the Corwen incident, republicans protesting against the Jubilee fired a 25ft-high beacon on Cadair Bronwen 23 hours earlier.

Throughout yesterday volunteers and water authority officials worked to rebuild the fire, so that it could be lit by Mr Emlyn Hooson, MP for Montgomery, late last night. A girl speaking Welsh rang the Western Mail yesterday to say the beacon had been lit by a group of republicans as a protest against the jubilee. She refused to give her name.

August 1978

GOLDFISH CRUELTY

Actors on goldfish cruelty charge

TWO actors were accused of ill-treating a goldfish when they appeared at Cardiff Magistrates' Court today.

Nigel James Watson, aged 29, of Penylan, Cardiff, and Stewart Cox, of Aberystwyth Arts Centre, University of Wales, were separately accused of cruelly ill-treating an animal – a goldfish – on June 22.

A producer, Ingar Bjarnason, was accused of aiding and abetting in the alleged offence.

1978 AUGUST

PUB VETS CUSTOMERS

Landlord vets his dole day customers

A CARDIFF city centre landlord has started closing his doors early on Thursday afternoons and vetting the people who seek admission.

He says problems have revolved around a "hard core" of people who pick up their unemployment benefit in Westgate Street on Thursday and head straight for his public house with the cash.

Don Best, landlord of the Queen's Vaults, said: "I am not tarring everyone with the same brush. I have allowed in some people who have probably been unable to find a job. But there is a certain element, who can cause the trouble."

Mr Best added: "I found – and I think this is something totally wrong with our system – that people left the dole office, went to the Post Office and cashed their Giro cheques and then came straight here ordering their double vodkas or Bacardis.

"The basic problem was their appearance – they looked undesirable and often made a mess.

"It was going to stop clientèle that I wanted to attract coming in here."

November 1978

MICKY MOUSE

Mickey Mouse ordered out

Mickey Mouse was ordered out of a special birthday party which had been laid on for children at a Christmas Fair being held at St Peter's Hall, Fairwater, Cardiff.

The children from the playgroup, above, had made a card to celebrate Mickey's 50th birthday during his visit but when Walt Disney officials heard that their star was due to appear before youngsters in a city church hall, they knew something was wrong. The real Mickey Mouse was due to celebrate his birthday at a special slap-up luncheon in London.

Walt Disney Productions manager Michael Rye swooped on the church hall to confront the vicar, the Rev Mervyn Davies, and, after a behind-closed-doors meeting, the substitute Mickey – Cardiff housewife Glenys Hubbard – was ordered out of her costume.

Said Mr Rye: "Mickey just cannot be in two places at one time and, as he is in London, he simply cannot be in Cardiff as well, it is impossible.

"Mickey Mouse is a star in his own right. To have two Mickeys is like saying there are two Richard Burton's.

"Even if a person dresses up in a Mickey Mouse costume and appears in public on a street it is – strictly speaking – infringing our copyright and therefore illegal."

Mr Rye added later that the card made by the children would be delivered to Mickey Mouse at Disneyland in the United States.

March 1979

DOG HOUSE

In the dog house....

Animal lover John Hill married his wife, Jane, only 10 days after their first date – but the wedding present he gave her has landed him in the dog house.

For since the wedding on February 27 John has been sleeping in a dogs' van with the present – a four-month-old Alsatian puppy Holly.

His wife is living at a flat in Claude Road, Roath, Cardiff, where there is a "no pets" rule.

Normally, faced with a predicament of that kind, a newly-wed couple would either turn to the RSPCA or a local authority housing department for advice, but John is secretary of the Cardiff and District

branch of the RSPCA and clerk to the Vale of Glamorgan housing committee.

The whirlwind marriage started when John wanted some typing done for work and 19-year-old Jane offered to type some letters and as a thank-you, was taken for a drink by John on Saturday evening.

"He proposed the following Thursday, we took out a special licence on the Saturday, and we were married on Tuesday – just 10 days after we first dated." said Jane.

"Just a few days before John proposed I moved into a new accommodation and when John gave me the puppy we discovered pets weren't allowed so he's been sleeping in the van looking after Holly ever since."

John and Jane say the present set-up is certainly not helping them settle down to married life.

February 1981

AWOL FOR 50 YEARS

AWOL 33 years? Jim's been away 50....

A desertion of 33 years from the army, claimed earlier this week by a Barry man, is almost a tea-break in comparison to the AWOL achievement of Cardiff absentee Jimmy O'Brien.

After reading of cafe owner Francis Langford's absence without leave in Tuesday's Echo, he told us Mr Langford was definitely not the oldest deserter in Wales.

Irish-born Mr O'Brien, aged 66, left the army 50 years ago and is still waiting for the authorities to catch up with him.

"I joined the army when I was 15 and lied about my age," he said today. "There was a world depression on and no work anywhere.

"But the army life was too humdrum for me. I wanted to travel and so, a year and a half later, in 1930, I got out and joined a ship in the merchant navy," said Mr O'Brien, pictured above holding the Echo featuring the previous report.

Most of the rest of the half-century away from the Welsh Regiment he deserted has been spent working for a Cardiff dry-dock company and all those years he never came within a pipsqueak of being found out.

April 1981

NO PRESENT CHARLES AND DI

Prince Charles and Lady Diana will not be getting an official wedding present from the people of Cardiff – because the city's Labour Party thinks the money can be better spent.

Labour councillors who control the authority will be told: "Do not spend any money on civic celebrations."

The move is bound to cause a huge row and some Labour councillors will resent being told how they should vote on the issue.

But the decision was overwhelmingly backed by a meeting last night of Cardiff Labour Party – and councillors should follow their local party policy.

The meeting was attended by about 40 delegates representing the four Cardiff constituencies and trade union branches in the city.

April 1981

BUS WARS

Bus wars hit the capital

The cut-price bus fare war in Cardiff started in earnest with a private coach company claiming victory in the first battle against the city council.

CK Coaches, the first company in Britain to break the monopoly on public transport held by a council, claimed passengers were already leaving the city council service for cheaper fares.

Actor Stephen Lewis – better known as Inspector Blake of the television series On The Buses – officially launched the two new services, bringing some levity into what is a bitter rivalry between the company and the council.

CK was given the green light to run the hourly services after the Government revoked the part of the Cardiff Corporation Act of 1930 which was designed to protect the city tram service.

December 1981

SHOPPERS DEMAND MONEY BACK

Cardiff shoppers demand money back

Christmas shoppers hoping for a bargain bonanza were bitterly disappointed and besieged salesmen demanding their money back .

Attracted by what was advertised as a Christmas Special Sale, many of them spent £50 on goods they later said they didn't really want.

Some people paid £10 for a coin medallion the South Wales Echo had valued at £5, and others gave £5 without knowing what they were going to receive.

The sale at the Central Hotel, Cardiff, was advertised in the Echo and drew shoppers from Valley towns.

In the event, few of the goods were in evidence and none was available for people to walk in and purchase.

The advertisement said "Please note this is not an auction". In the end, however, the form was very similar. About 100 people gathered around a salesman who produced goods and asked: "What will you give me for this?"

Early in the sale, one or two people got what appeared to be bargains – one man a video machine and television for £99 – then throughout there was a torrent of sales talk.

"I'm going to make you people leave here bow-legged," said the salesman who described himself as "Billy Fairplay from Holloway".

As goods were produced, his assistants would shout "Governor, you can't sell them for that, that's giving them away."

Even when money was paid, the goods were not immediately handed over.

Those who gave £50 for a set of crockery, or reputedly silver tea set, a food mixer or a clock and two watches were left holding toothbrushes while Billy Fairplay went on to other items.

At one stage, he said: "Who will give me a tenner for what I'm thinking about?"

For that they later got a reputedly 22-carat gold coin struck by the Royal Mint and bearing a tag saying "recommended retail price £25".

An established Cardiff jeweller told the Echo it was just anodised metal, possibly gold-plated, but cheaply made and worth no more than £5.

The £25 price tag, they said, "must be wholly fictitious."

June 1981

MOUNTAIN LION

'Mountain lion' seen near city wood

POLICE are investigating reports of a mountain lion or cougar being seen in the Leckwith area of Cardiff.

Mr Peter Coburn, 45, of Leckwith Hill, was driving

home in the rain at about 11pm when he saw the "lion" in the light of his headlights, sitting on the lawn of his house.

He has since been in touch with the zoology department at University College, Cardiff, and is in no doubt that what he saw was a cougar.

A police spokesman said today that a number of similar sightings by residents in the area had been investigated in recent years, but nothing found. He said they were investigating the latest report and were taking the matter seriously.

April 1982

TREE CARDIFF CITY
Fans to keep their free view tree

A WILLOW tree overlooking Cardiff City's Ninian Park ground, has been saved from the woodsman's axe – thanks to a heart-rending plea from a young girl.

And now a group of teenage Cardiff fans can carry on watching matches from the "comfort" of their own little grandstand 30ft up in the branches.

The club had planned to chop down or prune the tree as part of a clampdown on supporters getting to see games free.

So when City's managing director Mr Ron Jones went to see the 50ft willow himself, and found it been transformed into a mini Grange End, he was all ready to send in the woodcutter.

But a small voice piped up: "You're not going to cut that tree down are you mister? It's the only place we've got to play around here."

Mr Jones explained: "There was a little girl swinging on the gate – she was only about nine. I don't know who she was, but I thought, 'How could we chop it down now?'

"The kids had put all these boards and back rests up there and, well enterprise should be rewarded. So I had a word with the chairman and we decided to leave it alone."

The tree is in the back garden of a house in Dunraven Road, just behind Ninian Park. The house's owner, 82-year-old Mr George Bale, allows the area's youngsters to play in the garden whenever they want.

The willow is the centre of all activity - ideal for swinging, climbing and jumping. It was planted by Mr Bale 45 years ago. He said: "I was a boy myself and know what it was like to slip into matches."

November 1982

OLD NORA
"Old Nora" found dead in city arcade

An elderly woman who was sleeping rough in Cardiff and was a familiar sight with her dog always by her side was found dead in a city arcade.

A lonely figure, she died with her only friend in the world - her pet - pining next to her.

But one of Cardiff's leading workers for the homeless, Fred Josef, said that everything possible that could have been done for Nora Bridle, known as "Old Nora", was done - at least for the last few years of her life. Cardiff City Council offered her three flats, the Wallich Clifford Community for the homeless, run by Mr Josef, wanted to take her in and many people in Cardiff Central Market fed her and her dog.

February 1983

CHAIN LETTERS

'Threat' in chain letters

A chain letter containing a veiled threat of death is circulating in Cardiff.

It says one man who threw the letter away died nine days later "for no apparent reason, apart from breaking the chain."

The letter, which was posted in the city, instructs the receiver to make 20 copies to send to friends and associates. No money is involved.

And it gives instances when people have received between £10,000 and £775,000 after sending the letter on.

One of the letters was received by Philip Warren, aged 24, who works as a messenger with the South Wales Echo.

"It came through the post on Wednesday, it was posted in Cardiff, but I don't know who by," said Mr Warren of Arabella Street, Roath.

"The letter is threatening... there is no way I am sending it on."

The letter said it had been passed around the world nine times and a polices spokesman said the letter should be ignored.

September 1983

RUSH HOUR STRIP

Residents' fears for woman neighbour

A WOMAN who strips naked in front of neighbours in shops, and wanders among rush-hour traffic in her dressing gown, is worrying residents on a South Wales council estate.

The police have repeatedly been called to help the woman, called Mary, back to her home.

But residents on the Hollybush Estate in Whitchurch, Cardiff, say they fear the woman, who is in her mid-fifties, will suffer a serious accident if the social services do not intervene.

October 1984

PUBS THE PITS

These pubs are the pits, say students

The student authors of a new guide to the public houses of Cardiff have made severe criticism of three.

And the assessments get a mixed reaction from the licensees of the Leather Bottle and the Bulldog in Fairwater, and the Dusty Forge in Ely.

A team of students at University of Wales Institute

of Science and Technology spent two months visiting more than 170 city public houses. They say they will not be returning to the three which they describe as "the pits".

The guide said the Leather Bottle – an Ansells public house – had the worst reputation in the whole of Cardiff and it is the sort of place to have your car stolen.

Landlord Mr Roy Parsons, pictured below left, who is keen to improve the image of the pub, said:

"A lot of boys in here have a reputation but the pub is quite tidy really. We do have the odd fight but it is usually strangers looking for trouble.

"The place is not half as bad as the Bulldog where the regulars are known by the police as the Bulldog Boys. It's full of people I've chucked out of here."

The Bulldog – a Brains pub – doesn't fair less well in the guide, which states: "It's on the edge of the notorious Pentrebane estate and attracts local hooligans.

Don't go there in the evenings, especially the night they cash their Giros. You won't last five minutes."

The Dusty Forge, a Welsh Brewers public house on Cowbridge Road, Ely, is described as: " A rough locals pub, very keen on all types of pub sports. This includes brawling on a Friday night."

The landlady, Mrs Shaw, said the students' comments were unfair because they had visited the pub for "about 10 minutes one lunchtime."

November 1986

BARRAGE

It's all go for Barrage and Cardiff Bay

The green light was given today for a barrage across the estuaries of two rivers in Cardiff which will transform a large area of the city.

A huge lake will be formed where the rivers Taff and Ely reach the sea and could provide the setting for a new opera house, college, shops, restaurants and housing.

The river Taff will have a permanent high water where it runs through the city in the most exciting scheme for Cardiff since the building of the civic centre at the turn of the century.

Mr Nicholas Edwards, Secretary of State for Wales, said the aim was to exploit the full potential of Cardiff's "magnificent situation" by the sea.

December 1986

SWIMMING AIDS BAN

AIDS sufferers: Swimming ban

NOTICES warning AIDS sufferers they are banned from using swimming pools run by the Sports Council for Wales have been posted in all their centres

And it looks like the row – which affects the National Sports Centre in Sophia Gardens, Cardiff – will not be resolved until the new year.

The Welsh Office is believed to have given the Sports Council the all-clear.

But officials at the council's Cardiff headquarters say the contents of the Welsh Office letter – which have not been revealed – will not be discussed until January at the earliest.

The notices say: "Pending guidance from the Welsh Office the Sports Council for Wales wishes to advise patrons that until further notice persons suffering from AIDS are not permitted to use the swimming pool or changing rooms."

The lock-out immediately sparked a furious protest from AIDS campaigners who condemned the move as "scaremongering."

January 1987

BIG MAC

The Big Mac is coming to Cardiff – MacDonald's hopes this year to open its first fast-food shop in the city.

The world's largest hamburger chain has bought a site at the castle end of Queen Street and the

outlet will provide more than 70 full and part-time jobs if planning permission is given.

May 1987

SHARES

Shares errand teacher warned

A TEACHER at a Cardiff school has been officially cautioned for asking a 14-year-old pupil to queue for Rolls Royce shares for himself and other teachers.

And the teacher at Fitzalan High School, who as not been named, has apologised personally to the parents of the fourth-year pupil Lisa Smith, who waited for more than an hour outside the National Westminster Bank in St Mary Street, Cardiff.

She was stopped by the teacher on her way to school and driven by him into the city to join the queue in place of another teacher. Later, a teacher drove her back to school.

July 1987

ROCK IDOLS PREACH TO THE CONVERTED

The contrast with the David Bowie concert was stark – there was no extravagant stage sets, unnecessary histrionics or polite hand claps for U2.

Adulation and sheer naked emotion were the order for the evening, the

which incorporated a snatch of Bob Marley's Exodus.

Every song became a shared experience as the fans roared along in unison with Bono, who strode across the stage like a demented preacher, arms outstretched and head held back.

The drama and emotion can't be understated – one look at the rapt, smiling, even ecstatic expressions on the fans' faces lifted the show well above the tacky rock vaudeville performed by so many bands these days.

There was only one tacky moment: "This is to the people of the greatest singing voices in the world," said Bono predictably, before launching into The Beatles' Help, one of several 'borrowed' tunes.

The night belonged to U2, whose encore was the devastating high spot of their high-powered show.

audience exploding into a mass of pushing arms and heads as the band walked on stage to a deafening roar of 55,000 fans yelling along to Stand By Me.

Before long, U2 were delving into the Joshua Tree album, with Trip Through Your Wires closely followed by I Still Haven't Found What I'm Looking For,

Bullet The Blue Sky was sung with moving intensity, Bono putting the violent song into context with his "San Salvador" cry whilst the lights swept across the crowd like a scene from Apocalypse Now.

"This has been a special night and I won't forget it – and hope you won't forget it," cried Bono at the end.

September 1987

LODGER

A horrible husband – but now he's a lovely lodger

Housewife Miss Elizabeth Morgan has taken on a new lodger – her ex-husband.

Ten years after getting divorced, Miss Morgan and former hubbie Ralph Perkins are back together as landlady and tenant.

She cooks his meals, washes his clothes and cleans up after him – but then it is "goodnight" when the pair go to separate bedrooms.

"Mr Perkins was a horrible husband but a lovely lodger," said 51-year-old Miss Morgan.

Even though the couple divorced after more than 15 years of marriage on the grounds of his "unreasonable behaviour", they have since made up their differences.

"We get on a lot better now than when we were married. As far as I'm concerned it works out fine."

And 59-year-old Mr Perkins said: "She knows how to look after me and I'm quite happy to be a lodger here."

But officials at the DHSS are not so happy about the set-up at Miss Morgan's home in Ely, Cardiff, and housing benefit of £35 a week has been stopped.

"When the inspector called, I told him we used to be married – didn't see anything wrong with that," said Miss Morgan.

"I said Mr Perkins wasn't getting any conjugal rights...I'm too old for all that nonsense and emotional upset."

July 1988

MICHAEL JACKSON CONCERT
Cardiff goes Wacko over Jacko

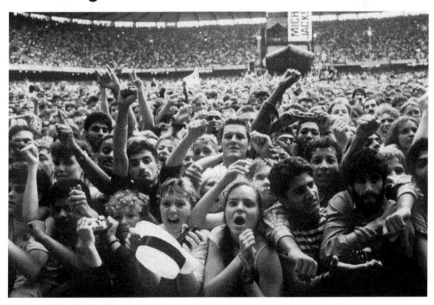

WALES has never seen anything like it – that was the promise and 55,000 ecstatic fans left Cardiff Arms Park in complete agreement.

Armed with some of the world's biggest hit singles, a larger than life image and a cult following Michael Jackson managed to surpass all expectations.

After just a couple of dance numbers came great Jackson ballads She's Out of My Life and the duet I Just Can't Stop Loving You.

For one girl plucked from the audience the night turned into a dream as she hugged and kissed her idol.

The next Jackson offering was a medley of snatches from "the old songs in the old fashioned way" including I Want You Back and I'll Be There.

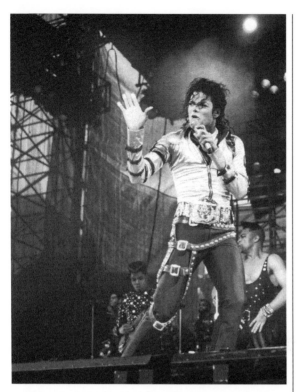

From the 1979 Off The Wall album came the smash Rock With You but the evening came to its first climax with a powerful Dirty Diana, currently riding high in the charts, and the Arms Park erupted.

Throughout the first set Jackson moved through a succession of costume changes, culminating in what everybody had been waiting for - Werewolf mask and baseball jacket - Thriller.

Complete with four superb zombie-dancers, the first set was brought to an incredible conclusion leaving the crowd desperate for more.

As night fell Jackson went into overdrive with the smash hit Beat It, driving fans wild when he loomed over the sea of arms on a boom, returning to the stage to bring to life the dance routines that made Jackson master of the music video.

Another eruption of cheers hailed the "moon-dance" known by millions from the Billie Jean video and a frantic scramble when Jackson threw the equally famous trilby into the audience.

1990 MAY

COUNCIL BOOB: IT'S NOT THEIR HOUSE...

Cardiff City Council has spent £9,000 refurbishing a house in Ely - which it doesn't own.

And now red-faced council chiefs have launched an inquiry to find out how one department didn't know that a pensioner had bought the house when work was carried out.

The biggest job was installing a central heating system.

Meanwhile the 80-year-old pensioner says she is left with mixed feelings about her unexpected good fortune. She said: "I'm really glad about the central heating and the new doors and windows, but I did not want the back and side dug up. They caused a real mess."

April 1991

CARDIFF DIAMOND GIGGS

Wales unearth a jewel in Ryan

Not even defeat could tarnish the glitter as Wales displayed another little diamond at the Racecourse, Wrexham, last night.

Jimmy Shoulder's Welsh Youth side suffered the first defeat of their European Championship campaign, losing 1-0 to a physically bigger and stronger England side.

But the occasion was most notable for the Welsh bow of Ryan Giggs, the Cardiff-born Manchester United player who, at 17, is already being hailed as a tremendous prospect.

The gifted striker, see in action above, did not disappoint. It says something for his reputation that he had two men on him every time he went near the ball.

Even then he occasionally bewildered them with a deft flick, sixpenny turn and a flash of pace, more suited to the race-course at Epsom, than Wrexham.

According to manager Jimmy Shoulder the English defenders were "mightily scared", though his phraseology was more Anglo Saxon in style.

It was a defeat, but Wales had by no means disgraced themselves on the night, which will surely be of most lasting significance because of the international launch of Giggs.

June 1991

DUCK CULL ANGER

They're not going to shoot the ducks!

The man at the centre of the controversy over shooting ducks on Cardiff's Roath Park Lake now says there will be no cull – three weeks after the row blew up.

City parks chief Mr Les Davies told the Echo last month he would consider a cull next year because the park was becoming over-run with "over-sexed" and "aggressive" mallard males, which had been "breeding like mad".

The idea of culling the ducks sparked an outcry from the public and animal welfare groups.

A group of 14 city councillors wrote to Mr Davies opposing the idea.

At a private meeting of the Labour-controlling group, some councillors held joke placards saying "save the ducks and shoot Les Davies instead."

But Mr Davies has now told the Echo: "It was never my intention to cull the ducks in the first place. I didn't say we would shoot them.

"In controlled waters, culling methods are used, but it is not an option for a public park in Cardiff."

He said the council had no other option but to let Mother Nature take its course.

June 1991

WALES BEAT GERMANY
A Night to Remember!

Welsh soccer was on top of the world after the all-conquering German football machine was brought to a shuddering halt on a euphoric night at the Arms Park.

Wales' sensational 1-0 win to strengthen their grip on the European Championship group five will send shockwaves throughout soccer.

The men Germany manager Berti Vogts rated as just "four out of 11" forced the former hard-man to eat his words with a top mark showing.

The world champions showed fallibility for the first time in 16 matches – and paid a heavy price for uncharacteristic ill-discipline as disaster struck following the 60th-minute dismissal of Thomas Berthold for kicking.

Within seven minutes Wales were ahead through a glorious Ian Rush strike. After that the Germans found goalkeeper Neville Southall in peerless form – Welsh passion, organisation

and the unique heady atmosphere of a sell-out Arms Park did the rest.

A world-class finish in a world-class stadium graced by world-class goalkeeping. The German world fell apart.

It was surely the greatest night in Welsh soccer history as Wales stunned the world by defeating their foe for the first time in nine encounters.

May 1993

WOLF-WHISTLE LANDS PAUL IN THE CELLS

Paul Powell lost his heart and his liberty when he wolf-whistled at a woman juror at Cardiff Crown Court yesterday.

He was imprisoned for 14 days after whistling at 22-year-old Alexa Hamley as she returned from the jury room.

The 19-year-old in the public gallery just pursed his lips and blew when he saw Alexa.

All eyes turned on the culprit as the piercing whistle resounded through the wood-panelled room.

He winked, she blushed, barristers smirked, some people smiled – and Judge Geoffrey Kilfoil saw red.

The furious judge – later accused by Powell's friends and a prison reform campaigner of overreacting – shouted, "Officers arrest that man."

The teenager made a dash for it, leaping over benches, through the foyer and out into the street. Officers from the adjacent police station arrested him 400 yards away.

Oxford-educated Judge Kilfoil, 53, ordered the man to be locked up over lunch while he considered how to deal with the contempt of court.

Shame-faced Paul, of Ely, Cardiff, apologised to the judge for his wolf-whistle.

"I'm very sorry," he said. "My friends and I had seen the woman juror and they talked me into whistling at her.

"I didn't realise quite how loud it was.

"Then I panicked and ran off when you ordered me to be arrested.

"I didn't mean to offend anyone. It was meant as a bit of a joke."

But the judge said he was not prepared to accept the apology, and sentenced Paul to 14 days for contempt of court.

After the case, Miss Hamley said: "I heard this whistling from the back of the court, blushed and put my head down."

August 1995

GOGS

Gogs pull in Levi 501 ad

Clay characters created by two Cardiff animators will be the stars of the latest Levi 501 jeans commercial.

A Stone Age family with disgusting personal habits will model the jeans in a 60-second ad, which will be on the television screen later this month.

The firm picked Michael Mort and Deiniol Morris of Aaargh! Animation Ltd to direct the advert after seeing their animation Gogs, which they made for S4C.

Michael said: "It's certainly different from anything Levi have done before."

August 1995

PRISONERS ABUSE

Cardiff jail neighbours suffer prisoners' abuse

Residents living near Cardiff Jail are being forced to keep their windows shut in the evenings because of prisoners shouting obscenities from their cells.

The problem has got worse during the hot weather. Some householders have been keeping their children indoors because of the foul language.

And 16-year-old Karie Parsons resorted to sleeping downstairs during her GCSEs because the noise was keeping her awake in her bedroom.

Her neighbour, Janet Davies, 40, said: "It starts once the traffic has got quieter and goes on until about 11.30pm."

David Ali, 28, who has two children aged two and four, has had to move one youngster out of a front bedroom because of the noise.

"My son was being woken up by all the noise. The shouting, swearing and abuse is appalling," said Mr Ali.

Prison governor Niall Clifford said: "We have tried to tackle it by putting steel grilles across the windows in the young offenders wing and are now in the process of fitting them in the adult wing.

"We will ask the prisoners not to make so much noise," he added.

June 1998

MANDELA VISIT

Mandela visit brings capital to standstill

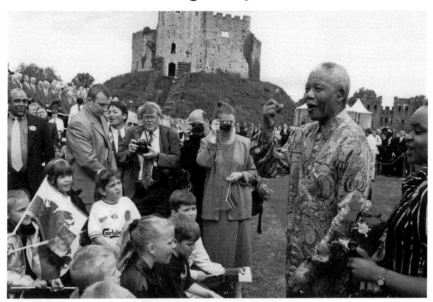

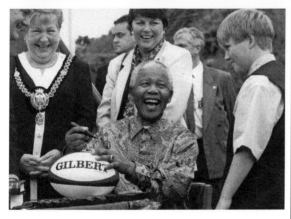

Nelson Mandela brought the Welsh capital to a standstill yesterday as thousands of people thronged the city centre to welcome him.

In unprecedented scenes more than 5,000 people packed Cardiff's Park Place to greet the South African President as he arrived at the Park Hotel.

The tight security cordon surrounding his arrival was shattered as the 79-year-old former prisoner of South Africa's apartheid regime, dressed in khaki trousers and one of his trademark patterned shirts, upstaged the nearby European Summit with an impromptu walkabout.

He made his way towards the ecstatic crowds and shook hands with shoppers who were moved by coming face to face with one of the outstanding figures of the 20th century.

Mr Mandela, who spent more than 20 minutes meeting the crowds, appeared relaxed and pleased by the warmth of

the reaction to his visit. Parents hoisted children over the crowd barriers to be touched by him.

Despite his advancing years, they were rewarded as he took many of the children in his arms and gently stroked their heads before handing them back to their stunned parents.

Shoppers, pensioners, students and office workers stood at times six deep, craning their necks to see him. There were tears from some as they tried to take in the symbolism of even just the briefest touch of his hand or a glance from his deep brown eyes.

Not since the first visit of Diana, Princess of Wales, to Cardiff have people turned out in such large numbers.

Speaking exclusively to The Western Mail, Mr Mandela said he was honoured to have been given the Freedom of the city. He formally receives it today. "I am very pleased, very pleased to have it," he said.

April 2000

GO-AHEAD CARDIFF GETS PRAISE FROM BLAIR

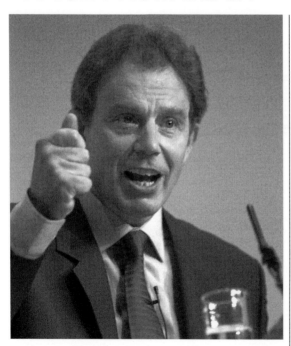

TONY BLAIR has described Cardiff as one of the most go-ahead cities in Europe.

The Prime Minister said developments such as Cardiff Bay and the Millennium Stadium have made the Welsh capital widely recognised as an exciting place to live.

Mr Blair praised the city during a phone-in interview on Red Dragon FM last night, in which he revealed he had earlier in the day just seen the first medical scan pictures of the baby he and Cherie are expecting.

He said the new sense of prosperity in Wales as a whole and in Cardiff in particular was due to the current stability of the British economy.

This needed to continue to provide wealth and growth in public spending to fund such things as education, the NHS and pensions.

Cardiff was reaping the reward of the Government's fiscal policies, he said.

"There is obviously still a lot to deal with and pockets of high unemployment and so on, but when you look at Cardiff now, it really is a fantastic go-ahead city.

"The stadium's made a difference, the waterfront development has made a difference, the Cardiff Bay development is going to be an amazing thing.

"It's reckoned to be one of the go-ahead cities of Europe now, there's no doubt about that.

"One of the reasons why Cardiff is doing well at the minute and Wales is doing well is that the economy has stabilised.

"That is delivering more wealth for people and that's the best way to get the money for the schools and hospitals – if you don't create the wealth you can't distribute it."

Apart from the family good news he shared with the audience of the Cardiff-based radio station, Mr Blair admitted that neither he nor Cherie knows the gender of the forthcoming addition to their family.

He also continued to equivocate on the prospect of his setting an example by taking paternity leave once the child is born.

"I'm in discussion, but the fact is you can't stop being the Prime Minister of the country, but obviously I have got to make time for the baby."

He said his daughter, Kathryn, was more excited about the imminent birth than either of his two sons, Nicholas and Ewan.

"I'm quite old to be having a child really, but I keep bumping into people of my age who say it's a fantastic thing."

March 2001

CARDS ON THE TABLE FOR POPSTARS NOEL

WAITER-turned-popstar Noel Sullivan is set to hit number one this weekend – but his old employer doesn't know where to send his P45.

Hear'Say star Noel, 20, earned just £776.60 last year – plus tips – from his job waiting tables at an Italian restaurant. But the band's debut single Pure and Simple has become the century's fastest-selling record.

Noel earned just £4.75 an hour just months ago before finding fame in the Popstars television programme.

His old employer Giovanni Malacrino at Latino's in Cardiff's cafe quarter is appealing for him to get in touch so he can officially "give him his cards".

Giovanni, 43, said yesterday, "Noel went from being one of my waiters to a

pop star so quickly I never had a chance to give him his P45 form.

"Once he was picked as one of the Hear'Say members, he was whisked away to a secret address in London and I didn't know how to get it to him.

"Now I'm appealing for him to get in touch so I can give him his P45 back, although the way he's going I don't think he'll be needing it anytime soon."

Noel's P45 reveals the singer earned £776.60 working throughout the year at Latino's in Cardiff's cafe quarter. The singer is set to dwarf his earnings this year with a number one single and an album due out later this month. The band have also announced an arena tour in the summer to capitalise on their image as real live singers.

Noel should have asked for his P45 back when he finished working as a waiter in November.

But he was so excited by his progress in the Popstars auditions he forgot about the form.

November 2002

WORST DRIVER AWARD

Worst driver's prize car goes up in smoke

A WELSH grandmother last night named as Britain's Worst Driver revealed that the car she won in a TV reality contest went up in smoke the first time she drove it. Kay Brown, 60, from Cardiff, thought she would be safe on the roads when she was presented with an elderly battery-operated car which reaches top speeds of around 30mph.

But on her first outing in the vehicle, which

she describes as "like the Flintstones' car", her 10-year-old grandson Christopher warned her that he could smell smoke in the back .

She said, "I had a cigarette in my hand when he said, 'Nanny, it's smoking,' so I said, 'Sorry about that darling, I'll throw the cigarette out now'.

"But he said 'Nanny it's coming from the back, I think your battery's smoking'."

The fault was caused when Mrs Brown charged the batteries up from her household electricity supply instead of using a special charger.

Mrs Brown, who passed her driving test on the sixth attempt after spending "thousands" on lessons, admits that she probably deserves to receive the dubious honour from the TV Channel Five programme which finished last night.

But she believes she is not as bad as fellow Cardiff driver Maureen Rees who shot to fame on the BBC hit show Driving School.

Mo spent £5,000 on driving lessons and finally passed her test on her eighth attempt.

The series followed the trials and tribulations of learner drivers, but it was Mo and long-suffering husband Dave's in-car pitched battles that captured the nation's heart.

Mrs Brown last night said, "I still can't reverse, I'll hold my hands up to it. I'd drive around for half-an-hour looking for somewhere to park up rather than reverse."

December 2002

INDIAN FEAST FROM CARDIFF IS HEADING FOR THE BIG APPLE

A former chef to Posh, Scary, Sporty, Ginger and Baby is putting a little spice in the lives of some of the world's top record producers today.

And, he is going to great lengths to ensure his feast is delivered and served to perfection.

Abdul Noor, who creates a wealth of tasty dishes for customers of the India Kitchen takeaway in Cardiff, has been commissioned by a London-based record producer to create a unique feast for 15 people.

What's so unusual about that, you may think?

Firstly, the producer, Tony Matthews, is paying for the meal to be flown all the way to New York to a function hosted by record producer Steve Francis, also known as Taxman – who has worked with top R 'n' B artists such as Mary J Blige.

Secondly, Mr Matthews is flying banquet chef Mr Noor out to the Big Apple to serve the meal himself. A fax for the abnormally large takeaway order was sent to the Caerphilly Road restaurant last weekend and management and staff instantly thought it was a hoax.

However, following a phone call to Mr Matthews in London, owner Abdul Nesar received a large cheque as an advance payment.

But why India Kitchen?

Tony Matthews was informed that Abdul Noor had done the catering for a party he had been to in London a couple of years ago, attended by a host of celebrities such as the Spice Girls and he had been hugely impressed with the food.

Mr Noor and the long-distance takeaway will leave Cardiff Airport this morning on a private jet to London. He will board a plane at Heathrow and will serve up the feast later this evening at a recording studio in Manhattan 3,339 miles away.

February 2003

PAID TO HAVE BEER ON THE BRAIN

HEARD the one about the student with beer on the brain?

Now, following a new marketing ploy, this could soon become reality, with one agency offering to pay students to display company logos on their foreheads.

Cunning Stunts, the creative marketing agency best known for projecting a naked image of TV presenter Gail Porter on to the Houses of Parliament, are asking cash-strapped students to wear a temporary tattoo on their heads for a week in return for nearly £90.

The only condition is they have to go out in public displaying the logo for a minimum of three hours a day.

Thus the company is hoping to exploit the stereotypical image of undergraduates needing to earn money, but wanting to exert the minimum amount of effort.

John Carver, director of Cunning Stunts, said, "A number of our employees have recently left university and these massive student debts are a real yoke for them.

"As part of our day-to-day work we set aside time to think up unusual, quirky and witty ideas.

"This one gives any participating brand a unique

advertising medium as well as giving something back to students."

Firms already signed up include lads' mag FHM and cable TV youth channel CNX, and initial university recruitment drives are taking place at Oxford, Umist in Manchester, Leeds, and Roehampton in London, and the scheme will be extended across Britain if the trial is successful.

Nial Ferguson, group marketing manager at FHM said, "FHM is constantly looking for new and impactful ways to communicate to men.

"If we can do this and pay for the next round at the union bar at the same time, then its seems a good idea to us."

Richard Kilggariff, head of CNX, said, "We want our shows to hit our viewers right between the eyes – so what better place to place an ad than on their foreheads."

Stewart Dobson, group marketing manager for Cardiff brewery SA Brain and Co, said it was always looking for new marketing ideas and would consider "foreheads as the new billboards".

"A pint of Brain's has been synonymous with student life in Cardiff for decades, although I don't know whether it was students who nicknamed SA 'skull attack'," he said.

"It would make it particularly appropriate to be advertised on people's heads though.

"We are in the middle of a large- scale marketing campaign based on positive thinking, and if putting our famous brand on their foreheads helped them to think positively, then that would be great.

"From a brand marketing point of view people are constantly trying to find new forms of advertising – for us billboard posters, broadcast media and our own merchandising in our pubs will remain by far our most common form of marketing."

But what do the students think?

Dave Mercatali is a 21-year-old student at Cardiff University.

He said he would definitely consider renting out his forehead space for extra cash.

"That sounds like a cool idea," he said.

"Nearly £90 a week would tempt quite a lot of students to try it, it's a lot less effort than working behind a bar in the evenings, and you could get on with your everyday life pretty untouched.

"Of course I would be embarrassed, but that wouldn't stop me."

Originally from Leicester , the journalism, film and broadcasting student said, "I would want some con-

trol over what I advertised though – I wouldn't want to do women's products, for example.

"Magazines and alcohol would be all right though."

Earth science student Chay Pointer agreed, saying, "I would give it a go – I think boys would see it as a laugh, whereas girls are more self- conscious."

Lewis Wray, 20, was very keen.

"I'm seriously considering it – where do I sign up?" asked the business administration student .

"I think it's a brilliant idea. I was just saying how broke. I am – it's easy money."

Tom McGarry, president of National Union Students Wales, said, "That's a lot of money, it would make a big difference to a lot of students.

"Some have got the possibility of getting work in other areas, but it would probably suit others very well.

"You would have to be a particular type of person to walk round with a logo on your forehead, but students need as much help as they can get at the moment.

"It's sad that some people may feel uncomfortable doing this but see it as one of the only ways they can earn money they need to get through university – but this is not as bad as some things students do to get by, such as turning to prostitution."

February 2005

HOTEL LOST PROPERTY

It's odd what people leave behind from a wedding dress to goldfish

GUESTS at one Welsh hotel have been taking the idea of "the lost weekend" a bit too literally – by leaving behind their wheelchairs, wedding dresses and false legs.

While Tony Bennett sang about leaving his heart in San Francisco, visitors to the Marriott Hotel in Cardiff have left a bizarre array of items in the capital on top of the usual deluge of umbrellas and toothbrushes.

The strange lost property haul – which also included a mannequin, a goldfish in a bag and breast implants – was revealed by general manager Derek Harvey , 45.

He said, "The most common items left behind in hotel rooms are mobile phones and glasses but, as you can see, there are some bizarre things forgotten too.

"It is hard to believe that some people bring these items into a hotel let alone leave them behind.

"Saying that, after working in the hotel industry for 25 years, nothing really surprises me.

"The wedding dress was strange because it was never collected and you would think that the bride would want to treasure her dress or at least sell it to get some of the money back.

"It also makes you wonder how some guests managed to leave the hotel without their wheelchair, white stick and false leg .

"One housekeeper was also shocked to find an undressed mannequin.

"It was just placed in the corner of the room so I don't know how they managed to miss it."

Mr Harvey said staff always tried to trace the owners of lost property but if items remained unclaimed after six months they were either kept by their finder or donated to charity.

Among the unclaimed items were the goldfish and the false leg , which, he speculated, probably belonged to medical staff attending a conference.

And Mr Harvey added that it was not unusual for guests, against the rules, to try cooking a midnight feast in their rooms, which probably accounted for an as-yet unclaimed camping stove and saucepans.

The findings complement a similar survey by the Travelodge chain last year, which revealed that an Olympic bronze medal, a harp, a Cartier diamond watch and a dog (which was eventually reunited with its owner) were among the most baffling items to be left behind in their rooms.

Memory expert John Aggleton, professor of cognitive neuroscience at Cardiff University, said being in unfamiliar surroundings could help explain guests' forgetfulness.

"When you have an automatic process you don't tend to check – the most obvious example is locking a car door," he explained.

"You don't make any conscious attempt to remember you've done it, so five minutes later you wonder if you've remembered to lock the car. We all make that error.

"But when it comes to what we leave in hotel rooms, there are other factors such as the speed guests have to leave because they're not up in time or

they might be doing some last-minute packing.

"I'm sure people have left all sorts of extraordinary things behind because people go into automatic mode unless they're the kind of person who will obsessively check in places like the bathroom.

"And people are in a different environment, using drawers they wouldn't use, in a hurry to get out, and they can't just use their standard routine, so they just forget to check their way through their room."

He added, "These items sound like the fruits of a student night out. The mannequin especially sounds really dodgy.

"But the two that stand out are the wheelchair and wedding dress.

"The wheelchair, obviously, because if you've got one you're not going to have a spare one with you, so why leave it behind? I've no answer for that at all. "And the wedding dress for the same reason – it's quite big and bulky, and you would expect the owner to have a strong attachment to it."

But even memory experts have their lapses, it seems.

Laughing, Prof Aggleton added, "I'm not sure I'm qualified to talk on this one – I tried to leave work without my shoes the other day until a colleague pointed it out."

Also Available from Amberley Publishing

This fascinating selection of photographs traces some of the many ways in which the churches of Cardiff have changed and developed over the last century.

Paperback

180 illustrations

96 pages

978-1-4456-1092-4

Available from all good bookshops or to order direct

please call **01453-847-800**
www.amberley-books.com